THE TWOFOLD COMMITMENT

THE TWOFOLD COMMITMENT

Trinh T. Minh-ha

Primary Information

CONTENTS

I. SEEN YET UNSEEN

Filmscript

II. SAY TO UNSAY

Conversations

1. SEEN YET UNSEEN

Filmscript

FORGETTING VIETNAM (2015)
Trinh T. Minh-ha

it
all
began
with
two

sea and boat

"leaving shore, boat and waterway
she's gone, our rower, to get married"
—Woman singing

sea and boat

what
would
they
be
without
each
other?

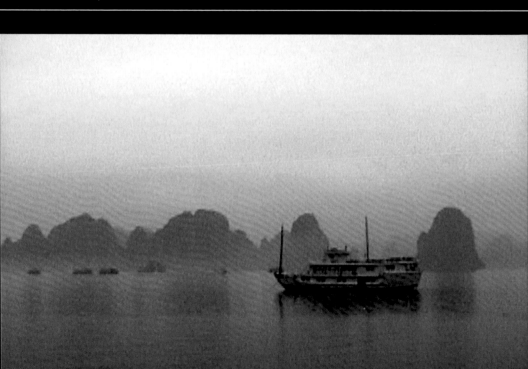

memory of a vast origin
movement of forgetting

leaving

returning

đất nước vạn xuân
land of ten thousand springs

return

ancestral dragon's body
water of legends

"Vietnam fever"

mountain and water
the founding gesture of Two
Two
Two forces

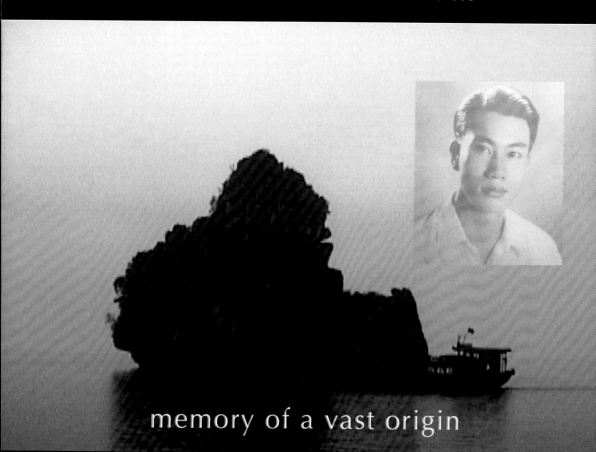

memory of a vast origin

Thăng Long
ascending dragon

Hạ Long
descending dragon

where the dragon descends into the sea

thousands of islets and islands rise
from the water

jewel of Vietnam's tourist industry

where to?

where from?

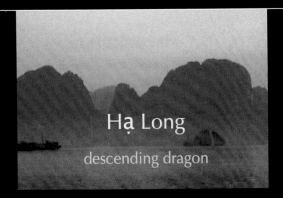
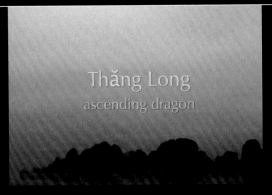
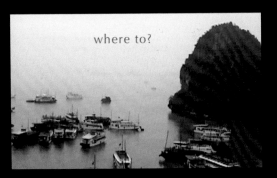
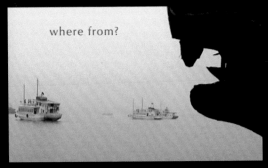

Our legendary ancestors, the hundred Việt, were born from
the union of a Dragon King and a Fairy or Mountain's Daughter,
Âu Cơ, who swallowed a handful of fragrant soil and lost the
power to return to Heaven

Her tears formed Việt Nam's myriad
rivers and the recurring floods are the
land's way of remembering her

"The New Vietnam

sea dreaming its solitude

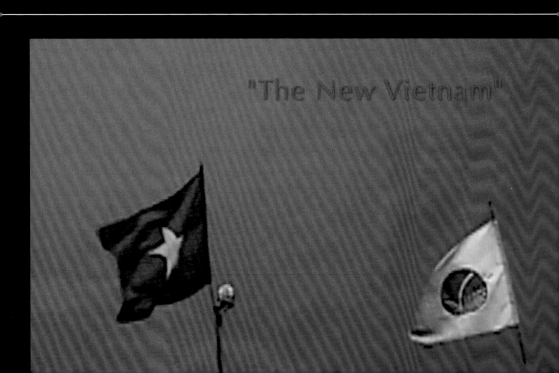

1995
Vietnam via Hi8 video

2012
Vietnam via High Definition Video

"the bigger the grain
the better the politics"?

camera memory for human forgetfulness
or is it the other way around?

scent and sound of memory

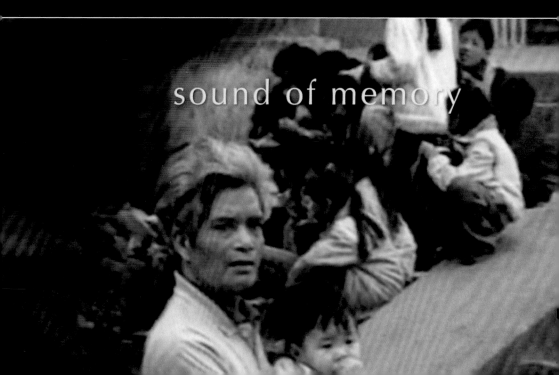

sound of memory

there are 'human markets'

people sit around waiting to be hired
all stay at popular boarding houses."
—Hanoi resident's voice

where does the real come in?

1995 twenty years after and yet...
2012 thirty-seven years after and yet...

where does the real come in?

t is said, the Party makes people its roots,

while people make the cutting board their roots

so the Party makes people its cutting board

recklessly chopping away."

—Hanoi bus rider's voice

"while people make the cutting board their roots"

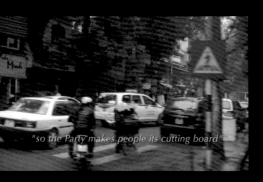

"so the Party makes people its cutting board"

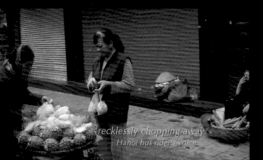

"recklessly chopping away"
—Hanoi bus rider's voice

Thăng Long
City of the Rising Dragon

Hà Nội
City within the River's Bend
ancient city garden
ancient city river
ancient city lake
"city of the socialist men"

a fragile equilibrium between land and water

Legend of Hoàn Kiếm
Legend of the Returned Sword

in time of peace
why hold on to the power of the sword?

Hồ Hoàn Kiếm
Lake of the Returned Sword
once part of the Red River

would today's King
return the Sword?

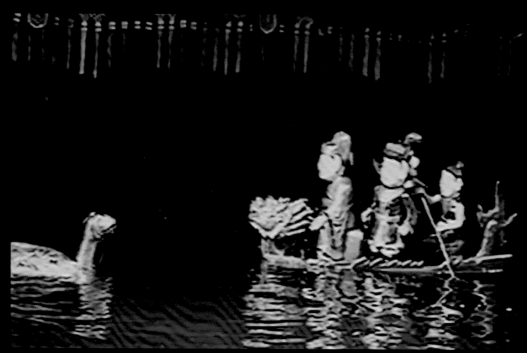

show tell

f o r g e t

life texture on water

water as stage

an ancient art
born in the Red River Delta

the water way

Thăng Long Water Puppet Theater

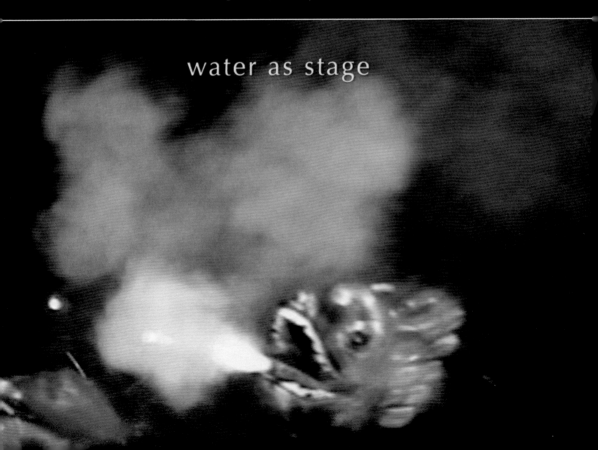

water as stage

Anyone messing around with our Vietnamese government
would be put in a car cage and dropped
never to be found again."

"It's the communist regime!"

"Already, they dropped so many in the East Sea
to feed the sharks. No name warriors!"

"—They call it 'disappearing with no traces left.'"

"Anything said must follow uncle Hồ's line."
"It wouldn't matter what one says
but why don't they help people?"
—Hanoi bus driver's and passenger's voices

"Anyone messing around with our Vietnamese government"

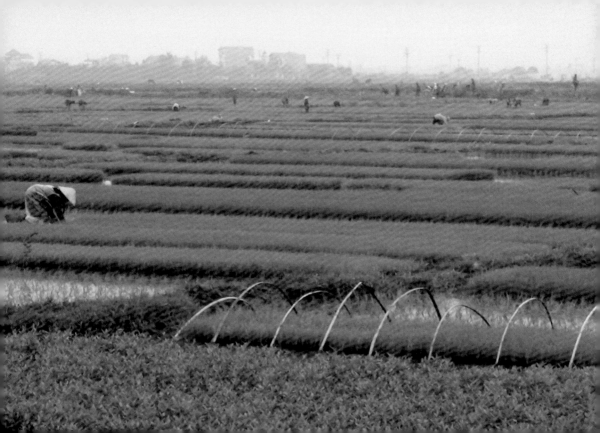

"Hạt lúa, hạt vàng"
"A grain of paddy is a grain of gold"
—Vietnamese proverb

"Ngày hai bữa cơm no / Đời vui như thế đó"
"Two rice meals a day / Such is a happy life"
—Vietnamese proverb

"One's from the North
One's from the South"

"Folks, take a rest
We are about to leave,"

"Now one heads north,
the other heads south,"

"Northern Hồ horse
with southern Việt bird"

"Oh, how sad"
—Quan họ (folk singing)

(ĐẤT NƯỚC)

land

lotus rising from ashes

r e t u r n

leaving

returning

her land
her country

scorched
mined
bled red

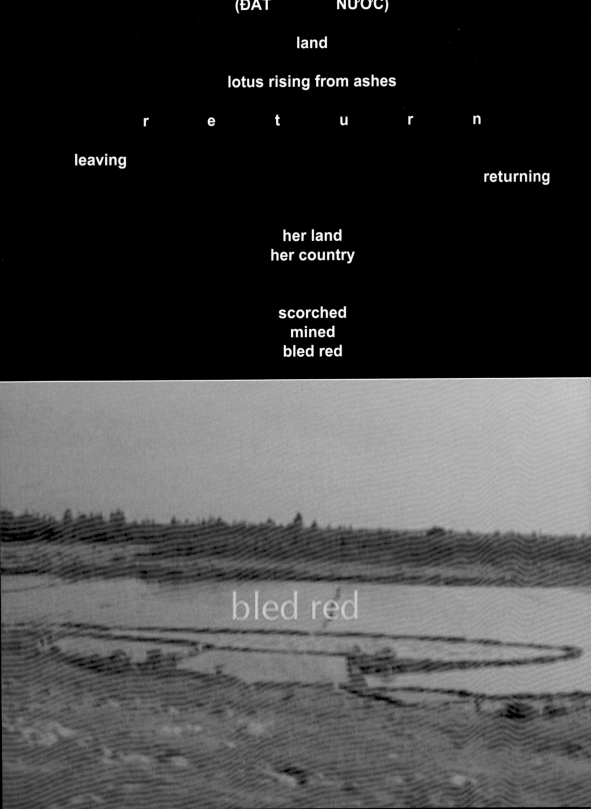

bled red

the survival of culture.
woman's prayer

lotus under watch

scarred
sprayed
contaminated

the earth r e m e m b e r s

r e m e m o r y

"Learn by Following Hồ Chí Minh's Exemplary Virtue"

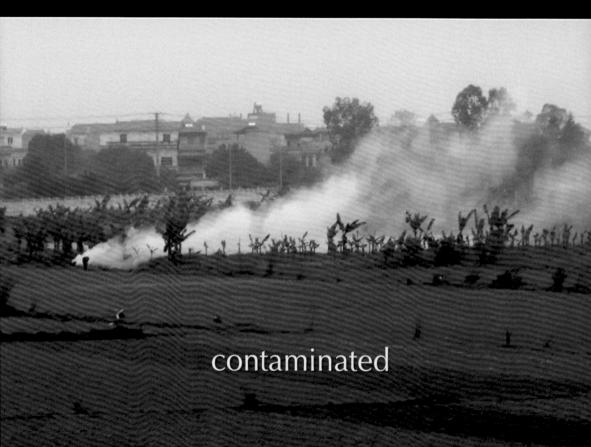

contaminated

twice as rice
from rice to rice sheets

bánh tráng artisans
turning dead alleys
into reproductive spaces

the knack for
threading one's way
through racks of rice papers

the earth remembers

r e m e m b e r s
the earth

between two
water and land

sites of memory and forgetfulness
receptacles of history's open wounds

can one simply place a war into a museum?

*"I am not asking for the sublime,
I want the terrestrial"*
—Clarice Lispector

ducks and rice fields
in eco-relationship

*"in haste
facing forgetfulness
facing a sigh
facing movements
facing hopelessness"*
—Thanh Thảo

where to?

between crony socialism and
the trappings of capitalism?

economic liberalization
and stringent political control?

civilizing campaign and
impoverished spiritual life?

popular symbol of Vietnam
of bravery and prosperity

"To really forget, we must fully know what we want to forget"
But how to remember the face of a war?
—Phạm Tiến Duật

In the current era of terror, Vietnam, for a change, is one of the safest places to travel to."
—Hong Kong's Political and Economic Risk Consultancy

"ăn có nhai nói có nghĩ"

"eating needs chewing, talking needs thinking"
—Vietnamese proverb

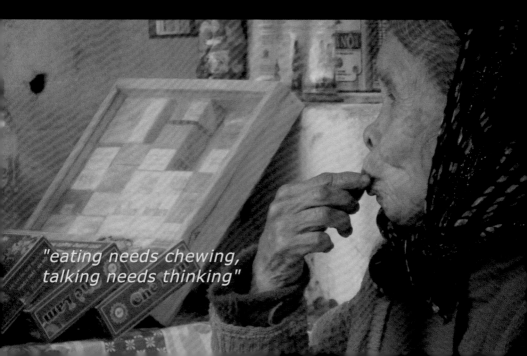

"eating needs chewing, talking needs thinking"

local market
women's city

where she s c a t t e r s the words

her images
her labor
her community

banned on commercial streets

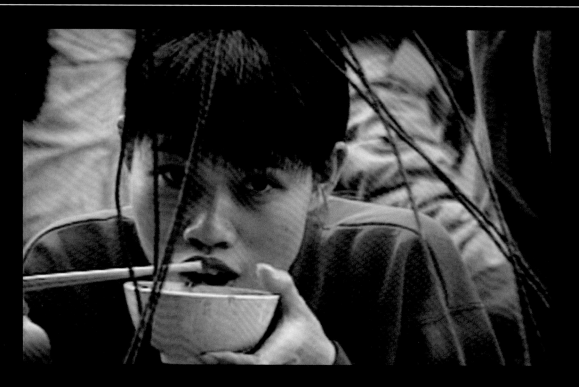

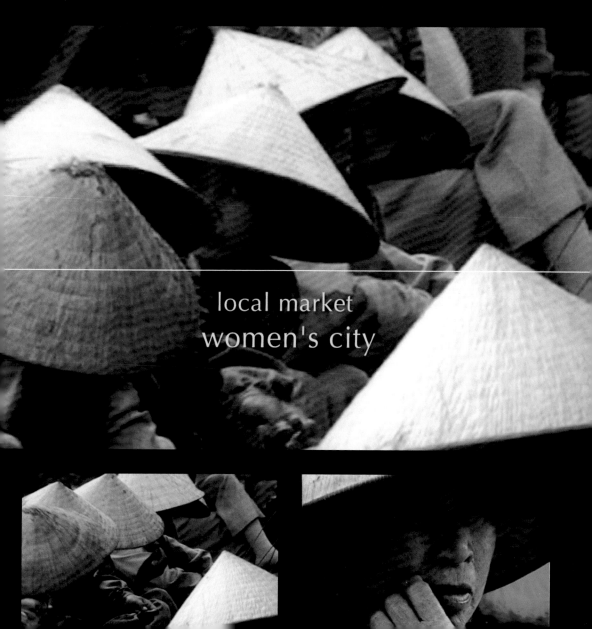

**mobile vending
a woman culture**

"a threat" to State modernization?

local market
women's city

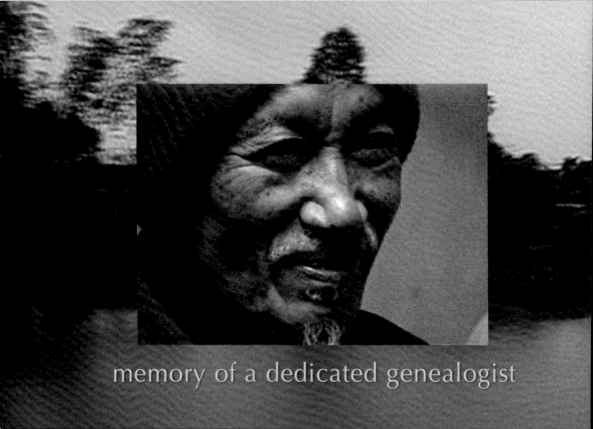

memory of a dedicated genealogist

silences

her pace
her rhythms
her voice

kindness

leaving

returning

— *"You look in good shape"*
— *"Now, the only issue is that
of memory"*

memory
of the future

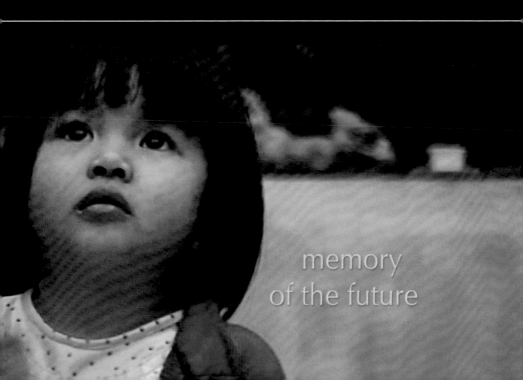

memory
of the future

"frog market"

i n a p p r o p r i a t e

to State images of order and development

"You never see them sacrifice a day of work"
—Dương Thu Hương

Can millions of veterans across countries forget?
Can the survivors of war trauma disremember?

scars of war have surfaced publicly
through increasing unearthed hidden remains

the wandering souls of the unclassified,
dismissed or "impure deads"

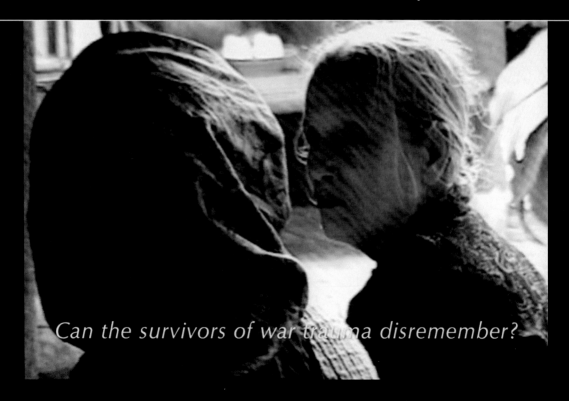

Can the survivors of war trauma disremember?

continue to populate
Vietnam's collective memory

"Here's the statue of Supreme Commander
Trần Hưng Đạo's second daughter.

She was a talented general,
gifted both as a scholar
and a warrior..."
—Temple staff

who goes to these temples?

She
who gives thanks

who sees the small in the large
and the large in the small

who speaks to the departed,
lives with the imaginal world
and in prayer faces the living

who visits these temples today?

the land shaped as
two enlaced dragons

*"Without donation,
no prayer will come true!"*
—Temple staff

*"The miracle is not to walk on water or in thin air
the miracle is to walk on green earth."*
—Thích Nhất Hạnh

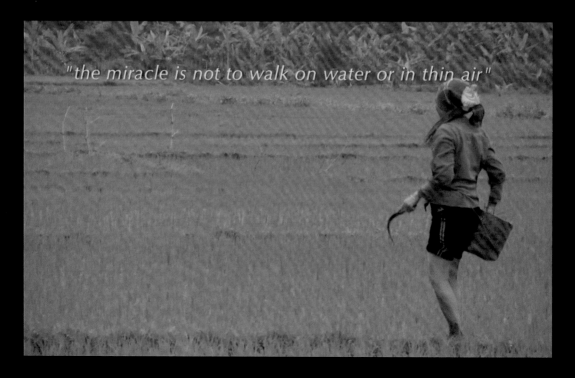

Outside/inside

installation and performance

dolls in glass boxes

in queen attires

She, He, Ze

gestures musical
social
gendered

between traditions and cultures
arrière and avant
past and post modernity

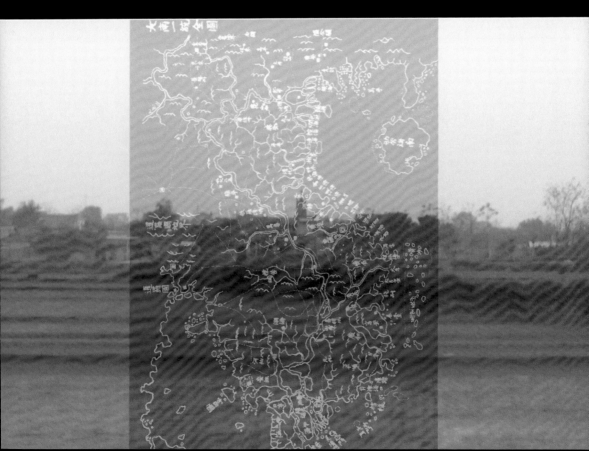

Nước Đất
water land
country

Đất nước
land water
country

"before blood, there is water"
—Saying

earth heeds
water dissolves

"Oh Huế, my city!
resounding with vivid singing voices..."
—Woman singing

survive

the ravages of history
the laundering of events
land's life force

r e t u r n

leaving

returning

murmurs
mournings
she who waits and weeps

classic images
of Vietnam

"The New Thailand"

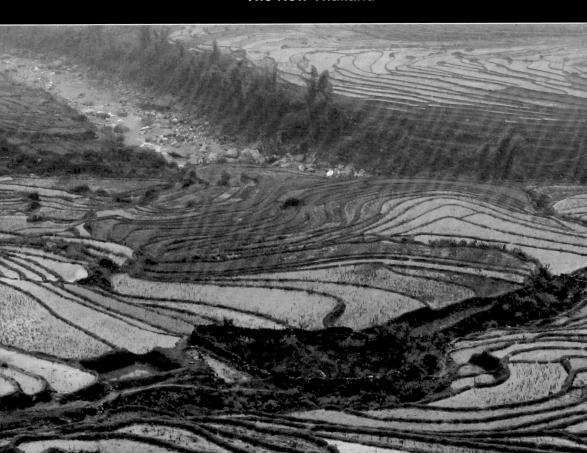

Huế citadel under constant reconstruction

the silent tears of Huế

 the thousands disappeared

 the mass graves
 mass burials

scattered in sand dunes,
children schools and rice fields

 tears the mouth can't say
 wounds the rain can't wash

 you need not hear nor see her cry

*"Huế's beauty lies
in the beauty of Huế's young woman*

*her lovable traits:
long silky hair, graceful walk"*
—Woman singing

*gentle speech, dreamlike virtue, sacrifice,
and more, up to ten traits...*

*as related in our popular
verses
to account for her dignified
beauty*

the grief

the sorrow

the suffering

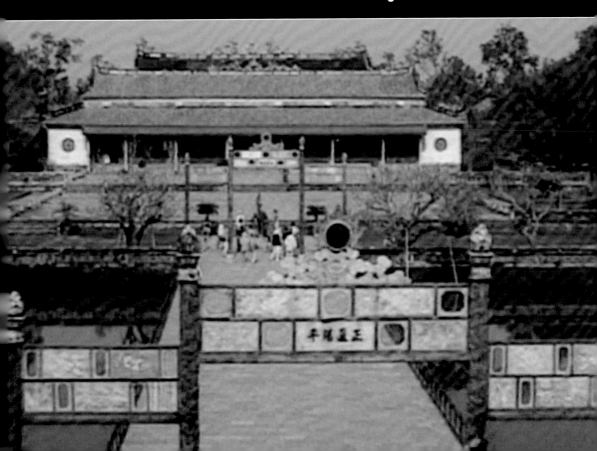

who eagerly re-members?

who hastily buries
and conceals?

The Perfume River witnessed one of the bloodiest
battles of the Vietnam War, the Siege of Huế in 1968

The Tết Offensive Massacre in Huế

"A myth"?...
with hard evidences

with massive impact
on the 1975 refugee exodus

almost every family in Huế
has a relative killed or disappeared during the war

During the communist takeover,
it is admitted US forces responded
by destroying the imperial city in order to save it

every year local people still mingle
Tết celebration with victims commemoration

following the mass exodus of the living
is the exodus of human remains since the 1990s

pagoda activities
under state control

19th-century map of temples in Huế

*"Huế is like a mute fairy
crying inside without speaking*

*I want to murmur to Huế and to caress it
but I'm afraid to touch the sensitive spot
on Vietnam's body"*
—Phan Huyền Thư

a thousand teardrops
Falling,
creating a sparkling lake"
—Trịnh Công Sơn

Sài Gòn, in HD
renamed HCM after Uncle Hồ

the hi-tech image
how cool do I look?
how fast am I?
how much faster can I be?

Sài Gòn, in Hi8

I'm losing you like a soul who has lost its name
like a river circling around its source
like one who leaves, far of sight, far of mind
secretly I wonder if you remember?...

..what's left today?
..what's left today?"

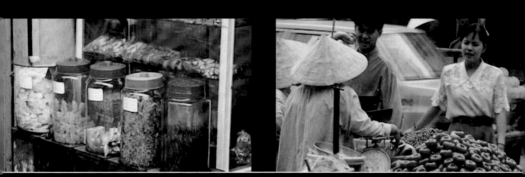

...what's left today?"

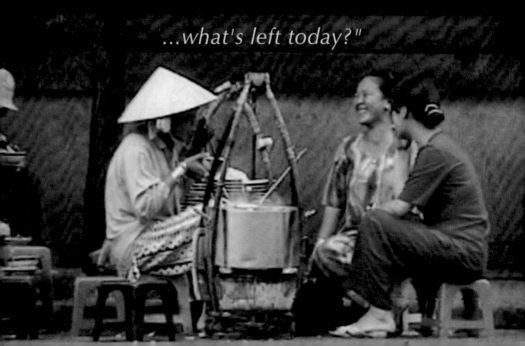

New Thailand on target

ghosts of war lurking in unexpected places

Cửu Long
Mekong Delta

**Sông Cửu Long
The River of Nine Dragons**

a densely populated waterworld

**where boats, houses,
cookeries, markets, gardens and theaters float**

**upon myriad rivers, streams and canals
—the region's arteries**

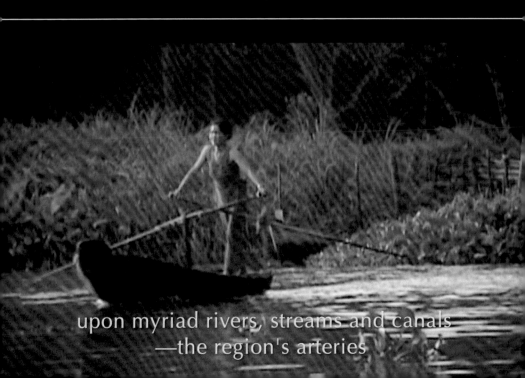

upon myriad rivers, streams and canals
—the region's arteries

You who are floating down the stream

let me tell you something

Let me confide,

to you, who are floating downstream to the east

I am not afraid of hard work

I can ride upstream through waterfalls

and downstream with rapids…"

—Quan họ (folk singing)

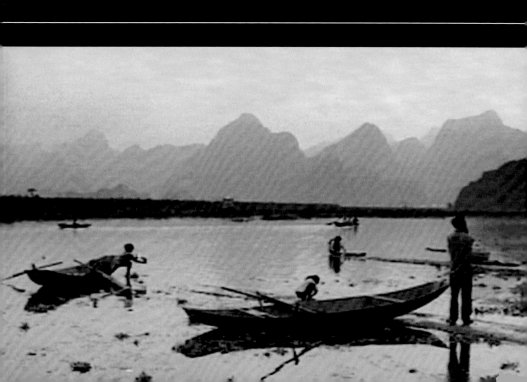

"Spring brings back memories

to this river's rower girl

she recalls three springs ago

when she made deep vows
to a loved one

but then that passenger
of a spring love

never returned to this
rivershore"
—Woman singing

"I want to cry like I want to vomit
on the street ...
I want to live like I want to die
among intersecting breaths."
—Thanh Tâm Tuyền

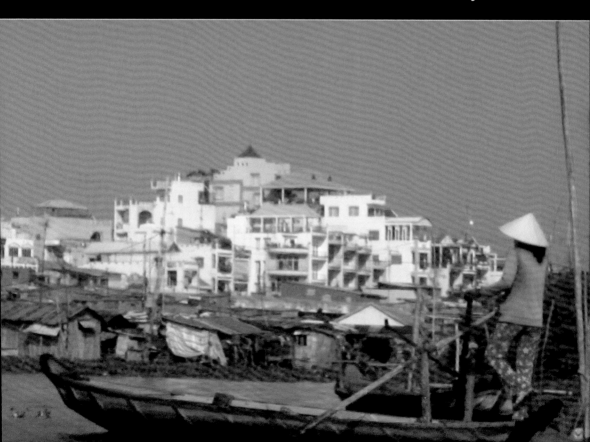

"leaving boat, shore, river,
she's gone, this rower"
—Woman singing

"Our people in the North have it rough,
because the land there makes it difficult to live

whereas it's so easy to live on Southern land
without hardship, we southerners are blessed from birth"
—Saigon taxi driver's voice

"Life has gotten much better now

but when compared with
countries poorer than us before
we are now worse off than them

the Vietnamese banknote now
falls even lower than the
Cambodian one!"
—Saigon taxi driver's voice

 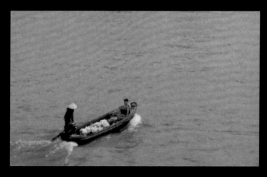

"Vietnam's most distinguished architectural creation"?

*"A source of inspiration and a dream house
for Europeans," said a Danish architect*

dream or survival?

*"Drop a thought into water
To reach a world of sand"*
—Nguyễn Quốc Chánh

For thousands of years
the ancient water has been flowing,
linking Vietnam to the land of its origin, Tibet

old and new

high and low technology
a difference of memory systems

Reclining Buddha:
remembering Shakyamuni during his last moments of illness

there's a dream dreaming you

a dream in which
all the dream characters
are dreaming too

the eye sees but sees not itself seeing

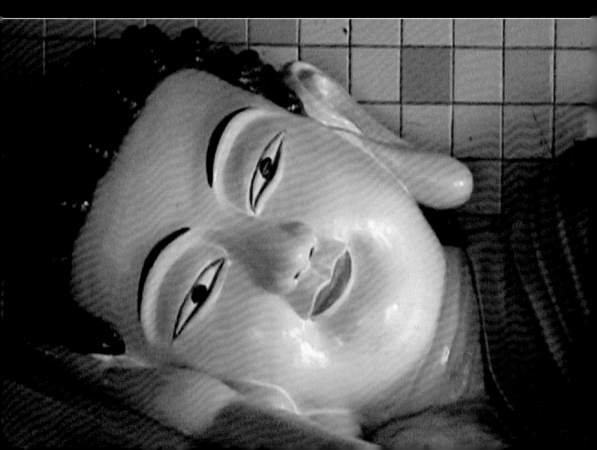

show and tell,
traces of what can't be seen

in night, the invisible light

the image, a singular experience of blindness

the bogey of
modern civilization:
Vietnam's increasing labor
export, sex trade
and human trafficking

"Why do they choose to be nuns?
Before...the war took place on the battlefield
now there's still a war, and it smoulders at the feet of Buddha"
—Phạm Tiến Duật

women's role in the renewal of religion?

back turning

getting lost

getting set

getting bored?

with state-sanctioned Buddhism
under Uncle Hồ's blessing

"Although Sài Gòn is hot, I am cool
Because you wore your white silk dress from Hà Đông
Oh how I still love that radiant hue
And how my poems still carry white silk

I still remember you sitting here, with short hair
The long autumn surrounding us then

My soul swiftly sketching your figure
Hastily engraving it deep in my soul
Your comings, goings, I knew them all"
—Nguyễn Sa, from "Áo lụa Hà Đông"

SHOUT

"a shout is a prayer for the waiting centuries"
—Thanh Tâm Tuyền

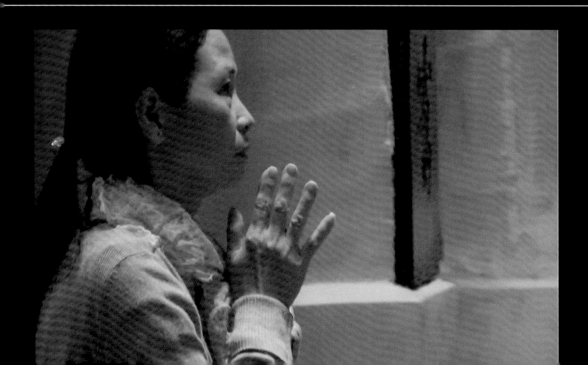

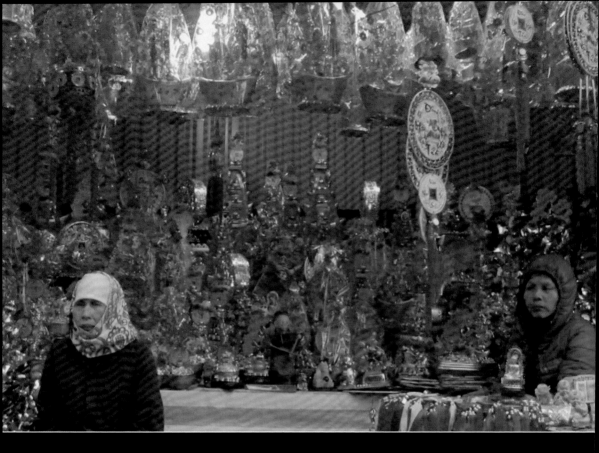

a myth surrounding the creation of Việt Nam
tells of a fight between two dragons
whose intertwined bodies fell into the South China Sea
and formed Việt Nam's "S" shaped coastline

Bách Việt
con rồng cháu tiên

peoples of Việt Nam
children of

immortals and dragons
mountain and water

Âu Cơ
Lạc Long Quân

memory
ɔ f w a t e r

what the skin
the nerves
the heartbeat
remember

Vietnam's lures:
her labor force
her brides
n the global marriage market

mer-mère-mẹ
the sea
feeds and kills

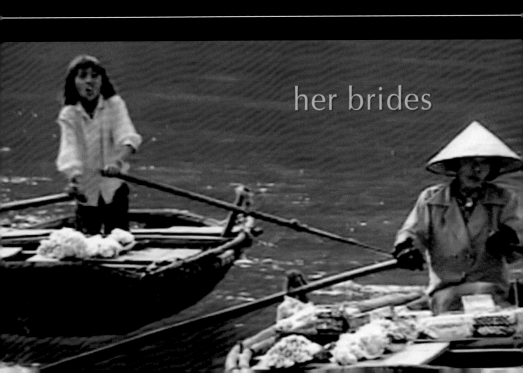

her brides

the East Sea,
Vietnam's lifeblood,

now endangered
with China's grip
on contested waters

people's livelihood at
stake in South China Sea
power dispute

flashback to the collective trauma
of fleeing across dark water

what drives millions of land
people into the infinity of the sea?

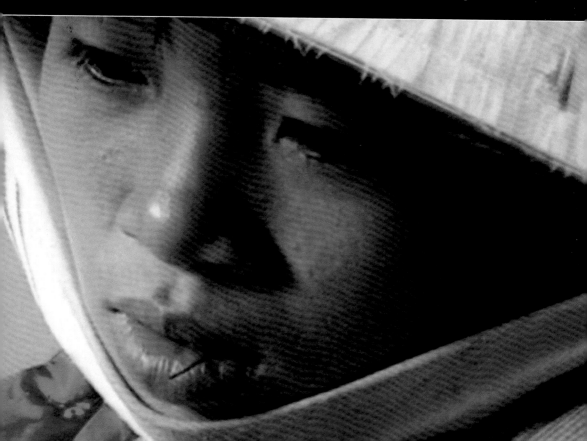

abandoning the terra firma
for the wavering path of globalization

in the incubative undercurrents

flow

unrest, dissidence, resistance

"Vietnam Fever"
how to survive the floods
of commercial appeal?

in the incubative undercurrents

post-renovation vietnam has attracted 7.8 million foreigners
a year with the largest group from China

—Where's the R?
—Here, all in the flag

images' own histories

North

South

the secret lies in the water
where bonds break and reform

more than a war
more than a victory

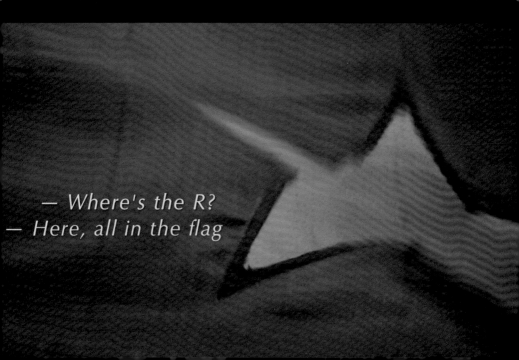

— Where's the R?
— Here, all in the flag

changing water
changing course
changing image

forwards

backwards

forwards

recalling yesterday's stories
to expose today's events

"blue mountains are walking
with their toes on all waters"
–Dōgen and Furong

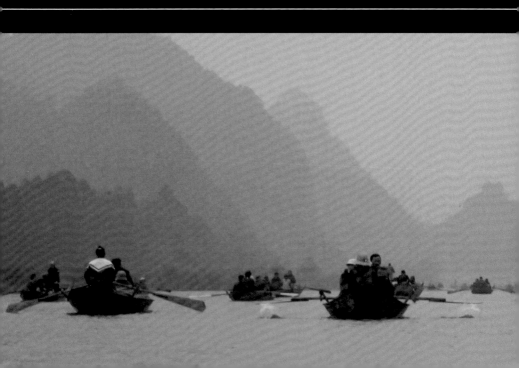

bring back 'my rower girl' to
US land"

*"the rower girl is central to
so many of our songs"*
—boat passengers' voices

the Red fervor?

whispering comrades
water dowsers
life givers

floating as antidote

where to?

The
specter
of
Vietnam

haunts
changes the world

where to?

in memoriam

Trịnh Đình Phi
(1928–2014)

Trịnh Thị Ngọc Lan
(1913–1997)

Vũ Trọng Khánh
(1912–1996)

Nguyễn Văn Tụng
(1921–2010)

Trịnh Đình Cát
(1923–2011)

Nguyễn Văn Thành
(1913–2001)

Trần Bích Lan a.k.a. Nguyên Sa
(1932–1998)

commemorating
the 40th anniversary of the end of the war
and its survivors

Forgetting Vietnam, 2015, 90 min., digital, color, sound.

Directed, written, and edited by Trinh T. Minh-ha
Produced by Jean-Paul Bourdier and Trinh T. Minh-ha
Camera: Trinh T. Minh-ha and Jean-Paul Bourdier
Music: The Six Tones (Stefan Östersjö, Nguyễn Thanh Thủy, Henrik Frisk, Ngô Trà My)
Quan họ (folk singing): Nguyễn Thị Bưởm
Additional music from DOI MUSIC, special thanks to Nancy Nga Tran a.k.a. Trần Thúy Nga
Sound design and music editing by Trinh T. Minh-ha

Commissioned by ACC Creation, Asia Culture Center (Gwangju, South Korea) and Haus der Kulturen der Welt (Berlin, Germany) for the exhibition *Interrupted Survey: Fractured Modern Mythologies*, curated by Anselm Franke and Joonmo Chung, on view at ACC Creation, September 4, 2015, to September 30, 2017.

Distributed by: Arsenal – Freunde der Deutschen Kinemathek, Berlin; Women Make Movies, New York; I-GONG, Seoul.

II. SAY TO UNSAY

Conversations

Design key: Throughout these conversations, green tabs along the edges of the page indicate indexed terms (see pp. 198–99), while green type highlights key concepts and ideas in Trinh T. Minh-ha's work.

NONBINARY: THE MANY TWOS

Conversation with Patricia Alvarez Astacio and
Benjamín Schultz-Figueora

Patricia Alvarez Astacio and
Benjamín Schultz-Figueora
(PAA/BJF)

In *Surname Viet Given Name Nam*
(1989), you present us with a story of
Vietnam, composed from the voices
of women whose experiences are often
left out of official history. In *Forgetting
Vietnam* (2015) you also complicate
official historical narratives [by] using
a wide array of voices—pop song lyrics,
quotes from activists, comments from
bus drivers, historical facts, etc. Both
films explore the properties of nam-
ing a country, what's contained in the
name, and tell a story from outside an
official history. Do you see this work
as a continuation of that earlier work?

Trinh T. Minh-ha (TMH) The entire body of my work can be said to exist in a continuum. While each film takes form in a precise context, and images carry histories of their own, independently from the history of the people concerned (as stated in *Forgetting Vietnam*), these films prevail in relation to a situated creative itinerary. It is very insightful of you to link the two films through the featured voices of the marginal and the unofficial. In my praxes across films, installations, and books, I have always merged the How and the What (as well as the When and Where), and your response to this film very astutely points to the politics of naming, rethinking what feminists used to call his-story, and veering from dominant historiographies.

For example, the opening and ending sequences of the film may offer images from famous touristic sites, but to focus merely on what is being shown without noticing how they are presented in relation to the instance of their consumption is to miss an important entry into the film. I am not referring here to aesthetics or to form versus content. On the contrary, in breaking with such a binary, I am drawn to the process of production within reception (and vice versa), and further, to the unknown within the all too familiar, or to the very ancient on the cutting edge of the new. How to open onto infinity within the finite has always been at the core of my work. This then means that there's also room to wander and err in my films, since they offer more than one entry or one exit, and the viewers who miss one could always catch another entry as they stay on with the work.

PAA/BJF

Forgetting Vietnam often centers on spaces that fall in between global ideological forces—as the voice-over says, "between crony socialism and the trappings of capitalism, economic liberalization and stringent political control, civilizing campaign and impoverished spiritual life." Can you

describe where you see these spaces in Vietnam? How are they able to exist in the face of these larger economic and political systems, and in what ways do you see them as openings that allow for change?

TMH "It all begins with Two," as one of the opening statements of the film says. Hạ Long Bay, for example, is not only the "jewel of Vietnam's tourist industry"—it is the site of encounter of two founding forces: Hạ Long, or "descending dragon," and Thăng Long, the ancient name of the city of Hanoi, or "rising dragon." Rather than referring to binary oppositions, Two designates here the ability to hold both. Mountain and river; solid and liquid; stillness and movement; masculine and feminine; dwelling and traveling; leaving and returning; North and South; low and high technology. These are some of the many twos activated in the film, which regulate our life in its mundane reality.

Feminists have long challenged the ruling patriarchal order and its mono-subjective culture of domination, production, and exploitation. They have advocated, instead, an order of coexistence, multiplicity, and mutual respect for both natural and cultural riches. Democracy lies in this ability to hold both, to break with the system of binary opposition, to take in the Other and question the phallic imperial One. The spaces you keenly point to in your response are those of the Inappropriate, the third term, the interval, and the *between two*—where among others, the feminist, queer, and postcolonial struggles could be affectively, ethically, and politically situated. Such spaces are not only to be found in Vietnam, but also, as you have already noticed at the outset, in the process of production—the way the film is created (or normatively dis-created).

Three examples from the film come to mind as we return more specifically to your question: the popular spaces, in Vietnam, of public transportation; of mobile vending,

mobile assemblage; and of what can be called insurgent poetry, disaffected art. These could be the spaces of fissures in the system, where the micropolitics of the small, mobile, and portable, of the ephemeral and the not-quite-not-yet visible is inscribed in the ordinary of everyday life. Difference is here actualized in such a way as to render impotent the grand politics of socialist and capitalist constructs. Even the legacies of transgressive art and its "political act"—central to the leftist West—are inadequate as framings.

When one is on the alert for the voices of ordinary folks, bus and taxi drivers and their conversations with passengers are the most telling sources of information on the political temperature of a country. Another location to have a feel of the motherland (rather than the "fatherland" as it is called among socialist men) is at the local markets, where, as stated in the film, women cook, sell food, and regroup to scatter words. Despite authorities putting bans in place to limit where street vendors can operate, mobile vending, known to be primarily a women's culture, remains a vibrant part of city life and an essential element of the country's cultural fabric. But recent state discourses about modernization and civilization in promoting urbanization have not hesitated to aggressively associate these trading street activities with backwardness and shameful underdevelopment, thereby threatening the livelihoods of a workforce predominantly made up of women. These "frog markets" are inappropriate to state images of public order. Overnight, street vendors thus become a menace and an obstacle to the government's effort at "beautifying the city."

Vietnam's literary milieu has always played a lively role in questioning state power, and so it is also through the voices of new Vietnamese poetry—antagonistic toward authority's abuse, disrespectful or simply indifferent toward proper norms—that one tastes the flavor of refuse and wreckage of the society. Many of the poets quoted in the film belong to Vietnam's postwar generation. Their words, firings of "foul open mouths," capture the noises, smell, sweat, and feel of

the streets. Their poetic vision and distressed dissident voices remain indicative of the cultural crisis and the tumultuous times Vietnam has gone through.

PAA/BJF One of these spaces also seems to be the temple or shrine. Can you discuss religious or spiritual spaces as political spaces, spaces of cultural survival and resistance? In the tradition of filmed ethnographies, religious practice is often a crucial "object" of study, but also the space where the filmmaker's distance from their subjects is most aggressively asserted (think of Margaret Mead and Gregory Bateson's *Trance and Dance in Bali*).

TMH Yes, I'm glad you mention resistance. Women's prayer is a visual thread that runs through the film. Again, this is a highly marginalized sector of modern society, despite the existence of numerous pagodas, temples, and memorials still functioning in the country. It's interesting that you link, albeit critically, such attention to women's culture to the tradition of filmed ethnographies and their obsession with religious practices, but the credit here is yours. As for me, I would just say that it's common for the secular, rational mind so entrenched in the power of reason to dismiss faith as mere religious belief or even as mere superstition, especially when practiced by women, or by the religious "Other."

A spiritual approach to life has almost nothing to do with institutionalized religion. When I look at certain women lose themselves in praying, I am first and foremost struck by the way they give themselves fully in the act of offering. One can often hear their earnest supplications, their ease in invoking the *imaginal* world, and their sincere immersion in the virtual reality of ancestral presence. There's also something to be said

in relation to a culture of bending, kneeling, spreading, and bowing, as compared for example to that of striving to stand erect, tallest, or on top. When seen in its daily deployment, such genuine acts of faith cannot be conveniently viewed as subordination to a traditional system of beliefs or as endorsement of premodern forms of hierarchy. To see openings for change in society, one has to change one's own seeing. Or more inclusively speaking, to effect change, one has to alter the way one takes in the world.

PAA/BJF

The film constantly reminds us of the complex relationships between human histories and the environment. Can you talk about how the forces of geography and ecology contribute to the political history of Vietnam that you are observing?

TMH

Such a vast question can be taken up in infinite ways. On the one hand, you have the older generation attributing Vietnam's geographically, ecologically, and politically intertwined fate to the workings of "karma"—very cursorily speaking, the cosmic principle of cause and effect generated by the people's intents and actions, and their impact on these people's future. They speak about the nation being both the theater of incessant wars under the Chinese, French, Japanese, and Americans, and the site of a multifaceted struggle with the forces of nature—floods, droughts, typhoons, year in and year out for millennia.

On the other hand, it suffices to look at Vietnam's landform, its long coastlines and its extensive network of lakes and rivers, to fully grasp the significance of the term *đất nước*—literally, "land water"—that stands for "country" in Vietnamese. But *nước*, or "water," used by itself, also means "country." So to refer to the government, people say *nhà nước*, meaning literally, "house water." Isn't it incredible when one thinks about the connotation of such an appellation? What

would a government be like, that would be so trusted as to embody home and its people's lifeblood?

Crisscrossed by hundreds of watercourses—the country's arteries and life force, as conveyed in the film—Vietnam is primarily a body of water. To portray it in its regional characteristics, one is necessarily led in the north to the Red River (Sông Hồng); in the center to the Perfume River (Sông Hương); and in the south to the Mekong (Sông Cửu Long, or the Nine Dragons River). Each being a multiplicity and having its own network of tributaries. So, what would it be for Vietnam to "look into Her own nature"? Aside from having an economy largely based on agriculture and fishery, what would it mean for Vietnam to follow "the water way"? And for those who show and tell, to *see* Her from the *sea*, in Her watery composition and liquid substance?

Through Vietnam's unique cultural manifestations, the film gives a range of feedback to these questions, all the while featuring a vital relation of the human to the nonhuman. Today it could be said, for example, that the terrible long war on land—of enduring national and international political reach—may have ended, but only to yield to another emerging war, *on water*. In the context of this discussion, the South China Sea dispute with Beijing could thus be apprehended in its full scope as it proves to be profoundly threatening, both for the people's livelihood and for their core legacy identity. War is not only a human but also an environmental tragedy of unending consequences.

PAA/BJF

There is a playfulness with language throughout the film. You bring up the concept of "rememory" in various instances—what difference are you pointing to between rememory and remembering, and between disremembering and forgetting?

TMH *All film images are images of memory—and of future memory.*

A journey into personal and collective re-membering never fails to raise questions about both the site of re-collections and the nature of the journey itself. The moment one gathers to show and tell is also the moment one starts the journey of forgetting, and not the contrary, as commonly believed. With the advent of digital technology and easy access to smartphones, tourists and shutterbugs need not exert their memory; they can rely on their phone cameras to remember for them. They can select, discard, or keep at will the images collected. And how much they can store memory depends on how much the recording device can hold. As stated in *Forgetting Vietnam*, old and new technology is primarily a question of difference of systems of memory.

People go to Vietnam to forget much of what they knew and recalled of Her, for only in disremembering can they continue to be and let Her be. However, it may be more adequate to say that Vietnam today is forgetting them. It is not unusual for many of us to unconsciously use homeland and memory to purge the violent emotions attached to our unbearable suffering, or to events of the war. Some set out resolutely to forget, but, as a quote from a poet says in the film: *"To really forget, we must fully know what we want to forget. But how to remember the face of a war?"* (Phạm Tiến Duật)

In going on living, or in visiting, returning, and photographing, we are already involved in the process of preserving and effacing—or of "Memory for Forgetfulness," as the poet Mahmoud Darwish wrote. Remembering is not retrieval of the past, but rather an active digging and receiving in the present. These are *acts of rememory* that can come in as many forms as manifested by the forces of imagination.

Here, documenting is both an act of memory against forgetfulness and a deliberate gesture of forgetfulness against memory.

PAA/BJF You often use the long take, which has been seen as a characteristic formal technique of ethnographic film. Yet your engagement with this type of shot feels quite different. Can you discuss your use or approach to the long take and duration in your films?

TMH I don't think the long take owes anything to ethnographic film and its illusory claim to objectivity with temporal realism, or its counter-claim to beyond-the-word sensory experience in observational approach. To mention just a few well-known examples of cinematic long takes that I have affinities for and find most challenging or unsettling: Chantal Akerman's framing of the minutiae of a woman's daily life in *Jeanne Dielman*; Marguerite Duras's sense of colonial leprosy and suicidal boredom in *India Song*; Tarkovsky's out-there journey into the Zone via paths felt but not seen in *Stalker*; or more astonishing yet, Aleksandr Sokurov's 87-minute, single-shot depiction of an uninterrupted ghostly walk across Russian history in *Russian Ark*, which remains a matchless tour de force. His is the quintessential long take that put to use the creative potentials of new technology.

What my films may have in common with the ones just mentioned could be located in the way the How and the What merge in the long take. Rather than holding on to temporal realism for truth effect or dramatic build-up of tension via expressive, selective cuts, I let the long take (in terms of both subject and duration) find its place in the rhythmic tapestry of layered time and temporalities, as well as of multiplicity of senses and meanings. The cut here is neither merely connective nor merely expressive in its function; it is in itself form—rupture as visual, musical, affective form. Each fragment can contain the whole, and the play between rhythms internal to the shot and external to it is also indicative of a way of receiving and creating rhythm that is not merely equated with montage

and editing. As an art of relations—of intervals and of strong, weak, syncopated beats—rhythm is powerfully social when it's at its creative best. And what ultimately comes with the sense of rhythm is the feeling of freedom.

PAA/BJF

What are your thoughts on the newest batch of "ethnographic" films that we've seen coming out in the past few years? Have you seen the work coming out of Harvard's Sensory Ethnography Lab (*Leviathan*, *Sweetgrass*, etc.)? What do you think of this resurgence of interest in an ethnographic framework?

TMH

These are very different films that cannot be generalized together. Instead of commenting on them, I would rather address the question you raise as form itself. Why focus on the ethnographic framework? Even though one of the areas directly criticized through my earlier films is "the anthropological eye" and ear of ethnographic practices, my works have always been at odds with categories. They don't fit adequately; they don't belong. So there's not much reason for me to return to this framework for discussion, when I have also engaged a wider range of questions around cinema through both what the film world calls "documentary" and what it classifies as "fiction," or "experimental" and "avant-garde" (to mention some no less skeptical categories).

I am aware, through the recurring questions I got around the alleged changes in ethnographic film practices, how eager certain anthropologists are to affirm that they have moved beyond what was found to be problematic in their naturalized conventions ("we are already doing all that [all the correct moves], so tell us about the changes you perceive in our current practice"). But it's not only a question of new versus old or of going beyond; it's also a question of critical positioning.

Further, with the decline of Western hegemony and its system of values, anthropology is not the only field at stake despite its direct historical link with colonialism. If one wishes badly to affirm anthropology's validity, its strength should be located in its very weakness, its instability, and the fact that it remains, at its best, under perpetual crisis. Ethnographers from the South or the non-West, for example, could be very sensitive to this, and the small differences they bring into their practices could make all the difference.

PAA/BJF

In a 1998 interview with Marina Grzinic you described an incident where an audience waiting to see Desmond Tutu were invited to sing "We Are the World," in which each chorus was adapted to a different identity. You worried that: "This is how difference becomes harmlessly decorative and how the media conveniently understands political correctness, using it in the name of multiculturalism to degrade multiculturalism." Given the current political climate—a presidential election that is largely discussed as hinging on issues of identity—how do you see the state of multiculturalism today?

TMH

I remember being alarmed by a warning from a Belgian-Syrian friend of mine, who said a couple months before 9/11: "Minh-ha, racism has just begun." When we talk about changes, are we merely rearranging some dead flowers, or are we planting a whole new breed of flowers—that bloom unseen, even during wintertime and in desertscape? Perhaps if, previously, as in the example you recall, some of us were eager to sing cultural

difference into a bland melting pot, today, with the rise of the police state and with friend and foe rhetoric alike in the new global security world, we can neither open our mouths nor whisper to ourselves without being shouted down by the bullhorns of corporate mind and surreptitiously charted on a graph by controllers of national databases.

PAA/BJF

Today your films—especially *Reassemblage* (1982)—are often taught in introductory experimental film or documentary classes. What are your thoughts on the ways that this work, and your early writing on ethnographic filmmaking, are currently taught in the classroom setting?

TMH

I hear in your question both the negative connotations of a co-opted margin, and the positive connotations of educational venues partaking in cultures of resistance and survival.

The familiar aphorism goes like this: "We are not meant to survive, but we're here and we're not going anywhere." A similar case is the book *Woman, Native, Other* (1989), which has been rejected by some thirty-five publishers but is now also widely taught in classrooms across disciplines here and abroad. One does not really control how one's work fares in the noncommercial world, at least it has not been my case. Neither can one hand over theory, history, and culture to the dominant by indulging in "pure marginality." People used to say despite the tribulations undergone, the true relevance of a work reveals itself over time. Edgard Varèse did not hesitate to declare that the public is routinely fifty years behind.

And yet, the question and answer should not stop there; we should go on and ask: How did the recognition of a film like *Reassemblage* change the conditions of film production and exhibition for the filmmaker? After having made eight

feature-length films, I am still struggling with every single project, large or small, to find funding, sizeable or teeny; and when I submit a work to film festivals, I still don't know where to put it so that the category selected would not work against it. The situation is far worse now than it was twenty years ago. Not only the funding venues for independent films—not made for TV and not conforming to the market's demands—have so dwindled during the eight years of Bush's presidency and ever since, but the film festival venues have also become so conservative that the few sporadic openings tolerated in the past have thoroughly closed down today. These are not only my thoughts, but also those shared by many film programmers, curators, and administrators. As *Forgetting Vietnam* asks at the end: "Where to?"

In anticipation of the screening of *Forgetting Vietnam* at the Rubin Museum of Art in New York in November 2016, this conversation with Patricia Alvarez Astacio and Benjamín Schultz-Figueroa was published in the *Brooklyn Rail* in October 2016 with the following introduction:

"Trinh T. Minh-ha has made a career of working between disciplines—troubling the foundational precepts of both anthropology and documentary. Her first film, *Reassemblage* (1982), and her written critical analysis of ethnographic methods effectively shaped a generation of debate over feminism, racism, empiricism, and colonialism in nonfiction filmmaking. *Forgetting Vietnam* (2015) is rigorously layered, covered in a dense haze of text animations, image overlays, and screen wipes that all clearly evoke the presets of digital editing software. None of the pristine pleasures of 16mm—the inhabitable depths of celluloid—are preserved in Trinh's HD cinematography. But the film still has the capacity to carry viewers away, to sweep them up in the river-flows of Vietnam's history and present. In these currents, the distinctions between poetry, philosophy, and pop music, grand historical events and everyday actions, are blurred. The ripples of historical trauma—from events like the Huế Massacre, which continues to haunt both the memories of those who lived through it and the city itself, as buried bodies continue to surface—are made manifest in quotidian images of workers and worshipers going about their daily routine."

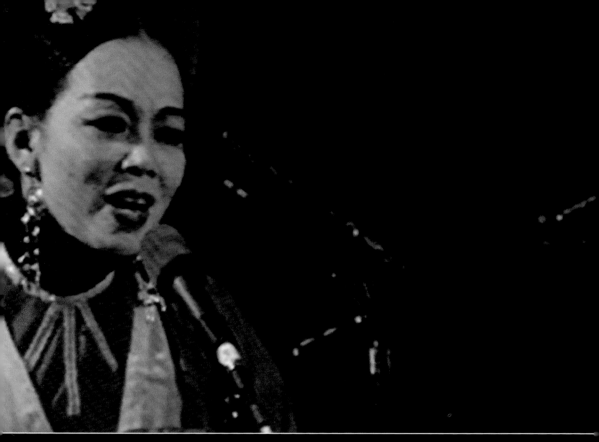

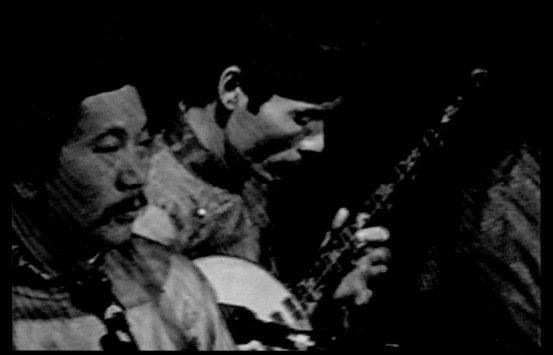

REALITY IS DELICATE

Conversation with Erika Balsom

Erika Balsom (EB)

You're well known as a documentary filmmaker and have written an influential critique of the genre; you have even said that there is no such thing as documentary. Could you elaborate?

TMH

I don't think of my films in terms of categories—documentary, fiction, film art, educational, or experimental—but rather as fluid, interacting movements. The first is to let the world come to us through an outside-in movement—this is what some call "documentary." The other is to reach out to the world from the inside out, which is what some call "fiction." But these categories always overlap. I wrote "there is no such thing as documentary" because it's illusory to take the real and reality for granted and to think that a neutral language exists, even though we

often strive for such neutrality in our scholarly work. To use an image is to enter fiction.

EB Another word that you often critique is "authenticity." Today, authenticity tends to be fetishized in contemporary art in a very uncritical way. The same is true, to some extent, in mass culture. There's even a book by business management writers B. Joseph Pine II and James H. Gilmore called *Authenticity: What Consumers Really Want* (2007). What, in your opinion, is wrong with it?

TMH Firstly, it has to do with power relations in knowledge: authenticity is always defined by the one who consumes the so-called authentic. It's almost always construed for the other. And, secondly, if the other is claiming it for themselves, such authenticity could either be a reaction to or a way of internalizing dominant values. That word still righteously circulates in the documentary milieu today with regard to films made on and from Africa, for example.

I made a film on Vietnam (my so-called native land or birth culture) titled *Surname Viet Given Name Nam*. You can tell immediately by this title that a national identity is not given but construed according to circumstances and contexts (here in its gender politics)—and the more you look into what you think is unique to your culture, the wider it gets. What is thought to be typically Vietnamese turns out to be not so typical after all. In the series of names shown and historically used to refer to Vietnam throughout the centuries, one can acutely discern the diversely political periods of colonization and foreign rule. One sees how the country's identity is, in reality, a multiplicity and an assemblage constantly being construed in the present. What is conventionally understood

as authentic is highly questionable because you can only be authentic if you confine yourself to locking doors and putting up fences.

EB
Instead of the authentic, you've always looked to the hybrid, the in-between, or the liminal. Recently, we've seen a return to identitarianism on the right and, on the left, a claiming of fixed and pure identity categories as the grounds for political action. Have you also noticed this reassertion of the purity of identity? Do we need to continue to make a case for the hybrid?

TMH
I see this very strongly in our quotidian, but also among students in some of the departments in which I teach, like Gender and Women's Studies and Rhetoric, or those that I'm affiliated with, such as Ethnic Studies, African American Studies, and Performance Studies. Amazingly, we went through a period in which we were really putting to task everyone who tried to assert forms of essentialism, to advocate authenticity, or to uphold fixed boundaries in terms of identity.

I went through this myself when I wrote *Woman, Native, Other*. I was very critical then of such rigid enclosures. But when the book came out and was discussed widely among people who claimed authority on identity politics, I could see how we needed to be more generous in effecting changes.

Even as we criticize, we should take into consideration the circumstances that lead someone to assume a black-and-white oppositional identity, especially among peoples of color. But to see it coming back today with a vengeance on both the left and the right, through the rise of white nationalists who are now given full rein under President Donald Trump to vent their racism and sexism, is very sad.

Alongside this renewed hardening of essentialism in identity politics, we also have the affirmation of terms like "intersectional," for example, among feminists of color. This arose from a strong commitment to understanding how, in relations of power, the embedded questions of gender, ethnicity, race, class, sexuality, religion, and culture overlap and intertwine. This approach was already at the core of my book *Woman, Native, Other* in the early 1980s, and the term is now popularized among feminists when referring to a more diverse and inclusive praxis. It's not new, but the fact that "intersectional" has received widespread attention today could perhaps help the struggle to regain momentum among intellectuals, artists, and activists alike.

EB In your first film, *Reassemblage*, the voice-over declares: "I do not intend to speak about; just speak nearby." What does this mean?

TMH If you are close to someone, like your lover or your mother, and you make a film about them, how would you show and tell? It's quite difficult. Every time you speak about them, you can hear the other person's voice challenging and protesting: "No, I'm not like that. What's wrong with you?" My mother, for instance, would certainly not recognize herself; she would deny, talk back, and try to rectify.

When you decide to speak nearby, rather than speak about, the first thing you need to do is to acknowledge the possible gap between you and those who populate your film: in other words, to leave the space of representation open so that, although you're very close to your subject, you're also committed to not speaking on their behalf, in their place, or on top of them. You can only speak nearby, in proximity (whether the other is physically present or absent), which requires that you deliberately suspend meaning, preventing it from merely closing and hence leaving a gap in the

formation process. This allows the other person to come in and fill that space as they wish. Such an approach gives freedom to both sides, and this may account for it being taken up by filmmakers who recognize in it a strong ethical stance. By not trying to assume a position of authority in relation to the other, you are actually freeing yourself from the endless criteria generated with such an all-knowing claim and its hierarchies in knowledge. While this freedom opens many possibilities in positioning the voice of the film, it is also most demanding in its praxis.

EB In your essay "No Master Territories" (1991), you reference Audre Lorde's idea that "the master's tools will never dismantle the master's house." You write: "How many already have been condemned to premature deaths for having borrowed the master's tools, and thereby played into his hands?" This is striking to me because I think that borrowing the master's tools is actually a very common strategy in a lot of contemporary practice. I'm thinking especially of artists dealing with digital culture who hyperbolically replay certain modes of visuality, attention, and experience associated with the Internet rather than try to forge any alternative to them. You insist on the need for new languages. Why is this?

TMH In every film I've made, whether it relates to my own culture or to another, the commitment to speak nearby has been extremely challenging. When you do not want to speak as a "knower," you talk with a lot of blanks and holes and question

marks. Perhaps you have no desire to fix meaning, which may sometimes lead you to a place of nonsense. But, in language, even when you work with nonsense, people find meaning. In my writing and film practice, I work simultaneously with sense and nonsense, and the new is often made to fare with the very old. It is naive to think that we can simply raze to the ground everything we have learned—which is a modernist delusion. Once you are colonized, it's not as if you can simply reject everything the colonizer has brought in. We unavoidably import, internalize, and adapt, often unintentionally, the master's tools and values. However, to put them to use when necessary is very different from unquestioningly letting them drive our political outlook on life.

In homage to Frantz Fanon, one can say there are three phases marking the struggle of the colonized and the marginalized. The first is that of assimilation—to survive, the dominated have to assimilate. The second is that of rejection—the younger generation often rejects with anger whatever their parents have assimilated, for example. The third phase, the most challenging one, is that of speaking "nearby," with, across, and in between: it is the phase of struggle. You can borrow the master's tools, as long as you know that you are merely borrowing for strategic purposes.

EB You often embrace the faltering of meaning. How are nonsense, confusion, or insignificance important to a postcolonial feminist politics?

TMH I frequently tell my students to voice their confusion in class— we are afraid to show our confusion in public, but much depends on how we respond to it. Confusion can tell us we are no longer satisfied with something that we were previously comfortable with, and can be a tool that is very nurturing and rejuvenating if we do not try to escape it. Nonsense, blanks, holes, and gaps could be manifestations of confusion, but they

also open up to new possibilities if we don't try to fill them with the pre-known and the familiar.

EB

This idea of confusion recalls *Surname Viet Given Name Nam*. In that film, you drew on Mai Thu Vân's *Viêtnam: un peuple, des voix* (Vietnam: A People, Voices) (1992), a book of interviews conducted in Vietnamese and published in French. You then translated these texts into English and had nonprofessionals reenact them. It seems that, in this process of translation, there's always an intentional betrayal of an origin or of a stable meaning.

TMH It is also a deliberate gesture to address the question of translation itself, or the question of language. Unlike *Reassemblage* or *Naked Spaces: Living Is Round* (1985), the use, in excess, of language in *Surname Viet Given Name Nam* highlights how verbal language can be destabilized despite its very dominant presence on film—how it can speak volumes about the talker rather than the other way around. In assuming we know all about our own cultures, we often take for granted that being an insider entitles us to speaking and asserting meaning with authority.

Language used in excess, both via the spoken and the written word, has an effect almost like that of memory: something that is triggered despite yourself. And knowledge in its ready-made assertions makes it very difficult to come back to a place of beginner's wonder—unlike the outsider who can often encounter things and events afresh, as if for the first time, and in silence (as I was in African cultures). But how to become a stranger in your own culture, your own territory, your own home? It's a real challenge to begin anew.

Nonsense can come with an overload of meaning: you can hear the sound of a word rather than its intended meaning. I could say "speak about" and you would hear "kabout." People have discussed at length this "speaking about" in relation to "speaking nearby," but nobody has commented on the repeated "kabout" in *Reassemblage*. In *Naked Spaces*, I stutter on the word "anthropology": the "ant-ant-anthropological." I could have edited that out but I left it in, because that was what happened in that specific moment of naming. I tried several times to say that word and I couldn't. And this sudden stuttering tells you volumes about how one could relate to that word and what it represents.

EB

You've published poetry as well as theoretical works, interviews, and texts related to your films. Do you make distinctions between your writing, filmmaking, and music?

TMH

I don't think of them as separate categories, but they have their own specificities. When you work with music, there are constraints that are unique to the medium, as with film and writing. I never think in terms of which is better: the way the work comes to me dictates whether it should be a film, a book, or a music composition.

It has always worked against me to have multiple areas of activity because people find it hard to classify. It's difficult, for example, for me to be accepted as a "normal" academic— not only because I have a parallel career as a filmmaker and artist, but also because my published work spans literature, film, art, music, philosophy, and anthropology. I like to use the example of typing. When you type with eight fingers, it seems very impressive. But someone who types with two fingers can also go very fast, and sometimes even faster than a person who types with eight. For me, it's not someone's many talents that are impressive, but how they use them.

EB In *Forgetting Vietnam* you use three
 video formats: Hi8, SD, and HD. In
 the past, you've made 16mm and
 35mm films. Technological change is
 in evidence across your practice, and
 you've also written quite extensively
 about the digital. I get the sense that
 you do not conceive of digitization
 melancholically, as a loss of tactility
 or of historicity.

TMH If I really wanted to indulge in melancholia, I would refuse
 to do anything digital and would continue to torture myself
 to find funds for 16mm and 35mm films. This was partly the
 case with *Forgetting Vietnam*, a project I began in 1995, when
 I went back twenty years after the end of the war.

 I was shooting with Hi8 video, which was the latest mo-
 bile technology at the time. In 2012, I returned to Vietnam
 to complete the shoot and it was the advent of HD video. I
 had a choice: I could have just thrown away everything I did
 in 1995, because the system of film festivals, art exhibitions,
 and television broadcasting does not really like Hi8—they
 consider it to be cheap and poor in resolution. But, from an
 independent filmmaker's perspective, Hi8 gives you a kind of
 saturated color that is unique to the medium: a grainy, paint-
 erly quality that you don't have in HD. HD is trying very hard
 to look like film (when it doesn't claim to surpass film), and
 it does succeed to a certain extent. It's a question of letting
 the old and new or low and high interact in their specificities,
 like I did in *Forgetting Vietnam*.

 Politically, such a choice has been very important.
 Making this film on Vietnam, I could see how the country is
 acutely struggling with low and high technologies and how
 the question of preserving the ancient while adapting to the
 modern is being played out in daily life. However, with new
 technologies, the old and the new are deliberately made to be

incompatible. Modernity's progress works by making every step forward a way of disabling and discarding older versions of the system, constantly forcing people to "upgrade" and hence to consume forevermore. Equipment that is just three to five years old is not "supported" anymore.

This is a dominant mindset in which incompatibility and mutual exclusion ultimately define the relations between low and high. Being critical of such an ethos, you could try a different ground for creativity and focus, for example, on assemblage or co-formation. In *Forgetting Vietnam*, everything is said to begin with the "two," the ability to hold both: the forces of mountain and water, of solid and liquid, low and high, old and new, north and south; the movement of ascending and descending, or of leaving and returning. These are nonbinary twos, the twos of multiplicity upheld in some of the pioneering feminist and trans writings.

EB And there are also memory and forgetfulness.

TMH Memory and forgetfulness are at the core of the project. Remembering is not opposed to forgetting. Again, this has much to do with the work of feminists, who have written at length about the "two" as differentiated from the imperial "one," with its mono-subjective patriarchal system of domination, subordination, and exploitation. In exploitation, one works at being on top: being the only one to do this or the first one, unique, the biggest, strongest, and so on. This kind of mentality has curtailed our freedom. Democracy has to be able to "hold both." When I included the two forces in *Forgetting Vietnam*—the descending and the rising dragon—it was in order to manifest the "between"—between water and earth—to hold the two in this betweenness, rather than to oppose them and fall back on a binary system that remains divisive at its core. Such is the schismatic political situation in the US today.

EB One of the pairs that you balance in *Forgetting Vietnam* is the land and the water. I was very interested in this ecological turn within your practice—one of many threads that we find throughout the film. What do you think feminism contributes to questions of environmentalism, ecology, or the Anthropocene today? And, to reverse the question: What do ecology and the Anthropocene bring to a decolonial feminist practice?

TMH The answer is related to what I said before about the many tools at our disposal and the forces of nature. When you do not conceive of these in binary opposition, but rather as forces that coexist and mutually sustain one another, then the human is not opposed to the nonhuman. Your comment on ecology relates to my latest book, *Lovecidal: Walking with the Disappeared* (2016), which addresses the climate disasters we are now experiencing. Something very specific led me to *Forgetting Vietnam* when I began the project in 1995: I was focused on the figure of a woman rower who takes people from one shore to the other. You experience this physically or spiritually—the shore can be that of life and death. The shore can be something very small, defining your ego or your small self, or something very large, where you are in tune with the world. It is very telling that in Vietnamese popular sayings and songs, as well as in legends and myths, the rower is, most of the time, a woman.

You can still recognize this starting point in the film; the woman is in the songs and is very prominent at the end. But by the time I returned to the project in 2012, my father was very sick. And in the process of completing the film, I lost him. The journey toward his death and his passing opened a door for me to what I call the nonhuman. Not that it was not there before, but his departure made it very intense for me. So, the film shifts

toward Vietnam as a body of water. This is evidenced in the thousands of rivers and waters that crisscross the country and the three huge rivers that define it: the Red River in the north, the Perfume River in the center, and the Mekong or the Nine Dragon River in the south. This water flows deep and wide, from the Tibetan Plateau to the South China Sea.

In the process of working with Vietnam as primarily water, the two forces catching my eye in the film are the sea and the boat: again, the human and the nonhuman. Here, it's not the person in the boat—neither the boater nor the boat passenger—but actually the boat itself and the sea. It's a way of shifting our attention to the fact that we are not the center of the world. Sometimes, viewers tell me they can't identify with the people in the film, which turns out to be mainly a reaction to the absence of interviews and personal stories. But this film is not about an individual story or about individual lives as representative of the culture—I was not presenting characters or the story of a few selected individuals. It's very much about water (or *nước*, the name that also refers to "country" in Vietnamese) and the "water way" in relation to the forces of nature as they define Vietnam, Her people, and Her culture.

EB What are you working on at the moment?

TMH I have six film projects I'd like to develop but have no funding as yet. Making a film can require a full year of work in terms of research, shooting, writing, and editing; but fundraising can take years and it's a real struggle. To mention just a couple of projects: one that I am making in collaboration with a group of Swedish and Vietnamese musicians, the Six Tones, concerns immigration as manifested through daily soundscapes and musicians' sound interactions. Another project, also dear to my heart, concerns the art, architecture, and culture of people's built environment in Yemen.

This interview was published in the November–December 2018 print edition of *Frieze*; it also appeared online under the title "There Is No Such Thing as Documentary: An Interview with Trinh T. Minh-ha." In both versions, the conversation was preceded by this introduction:

"Trinh T. Minh-ha's first film, *Reassemblage* (1982), is in some sense a work of ethnographic cinema. Shot in Senegal, it is filled with scenes of daily life, especially of village women. Yet, from its very title, which summons the fragmentary and constructed, *Reassemblage* signals that it will be no conventional documentary. Disentangling sound from image, forgoing an authoritative voice-over, and relinquishing the long takes of an observational style for a disjunctive montage aesthetic, Trinh overturns the conventions traditionally employed in anthropological filmmaking. Rather than a work of ethnographic cinema, *Reassemblage* is better understood as anti-ethnography—a film that reflexively dismantles the objectification and exoticization of otherness which mark the ethnographic and colonial projects alike. In the films, installations, and books she has produced in the years since *Reassemblage*, Trinh has continued in this spirit, deconstructing claims to identity, presence, and authenticity, holding them to be the product of patriarchal and colonialist epistemologies. Whether in the reenactments of *Surname Viet Given Name Nam* (1989) and the poetic theorizing of *Woman, Native, Other: Writing Postcoloniality and Feminism* (1989), or in her more recent turn to exploring digitization and climate change, Trinh insists on dislodging the illusory purity of inherited categories to make way for the hybrid and in-between. Crucially, this cross-disciplinary practice is not one of simple negation: Trinh breaks down dominant languages in order to imagine other forms of relation and expression. *Forgetting Vietnam* (2015) crosses the country of her birth from north to south, confronting changing imaging technologies and the ambivalence of modernization along the way. Through landscapes, history, folklore, and popular songs, this essayistic travelogue commemorates both the passing of Trinh's father and the fortieth anniversary of the end of the Vietnam War. The work possesses a lyricism not present in *Reassemblage*, but Trinh's words from the earlier film resonate in it even more strongly: 'Reality is delicate.'"

WARTIME:
THE FORCES OF REMEMBERING
IN FORGETTING

Conversation with Lucie Kim-Chi Mercier

Lucie Kim-Chi Mercier (LM)

You made three films around Vietnam; can you speak a little about the process that led you from one to the next? Is there a thread running through the different films, namely *Surname Viet Given Name Nam*, *A Tale of Love* (1995), and *Forgetting Vietnam*?

TMH

In terms of realization they are three very different films, but certainly, there are threads linking them together because they are all about "culture" in the largest sense of the term. Whenever I go to places and shoot in cultures different than my own, I'm not interested at all in "covering a story"—an individual's story or an individualist subject. I never work that way. I'd rather come into places and events with questions like:

What characterizes a culture? What is its everyday reality? What leads a country to be seen as such? And importantly, how do we show and tell (from what position, with what tools)?

Surname Viet Given Name Nam, as you can tell from the title, concerns the naming of a country. It has to do with gender and national identity, as well as with the politics of naming, translating, and interviewing. *Forgetting Vietnam*, which engages with the process of remembering and forgetting, also relates to the naming of a country by featuring the multidimensional roles of land and water. In Vietnamese, *đất nước*, the term for "country," designates "land" and "water," but just saying *nước*, or "water," already refers to a country (for example, *nước ta* means both "our water" and "our country").

I start from there, from Vietnam as a body of water—in its geological formation and via its people's economic and cultural activities—to commemorate its fiftieth anniversary of the end of the war. *A Tale of Love* is a film based on the national poem of Vietnam, *Kim Vân Kiều*. If there's one thing the Vietnamese diaspora across all nations remembers of the culture, it's this poem. It's unique because it speaks to people from all classes in all walks of life. Villagers know verses of it. They've become popular sayings and are widely cited in a host of circumstances, especially situations related to questions of gender and nation, virtue and loyalty. Even if people don't remember all 3,254 verses of the epic love poem (none could do so in any case), they do remember fragments pertaining to the distinct roles and deeds of the characters in the poem.

This was what I adopted in approaching the poem with my film: not illustrating it; not manufacturing a realist representation of it; not narrating it linearly from beginning to end, but offering a multitemporal, multilayered, music-for-the-eye work. Therefore, coming in from the middle, opening with the ear via the poem's closing verse, which deliberately states its function as a fabulation for beguiling the long night. What is emphasized is the nature of the poetic, hence the singing and recitation against a visual work that also invokes the olfactory

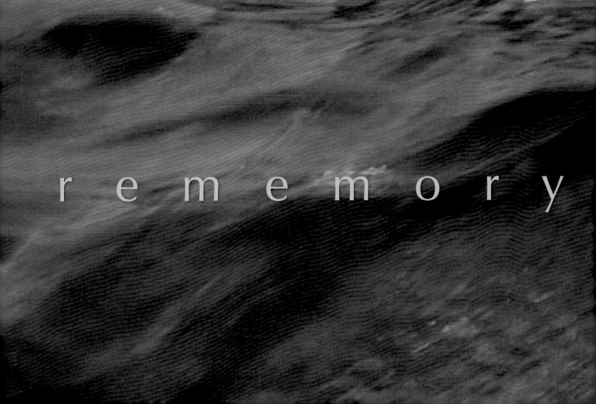

rememory

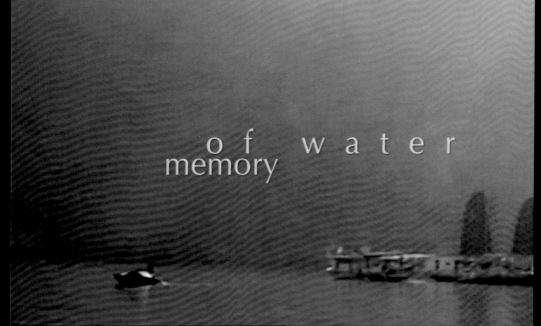

of water
memory

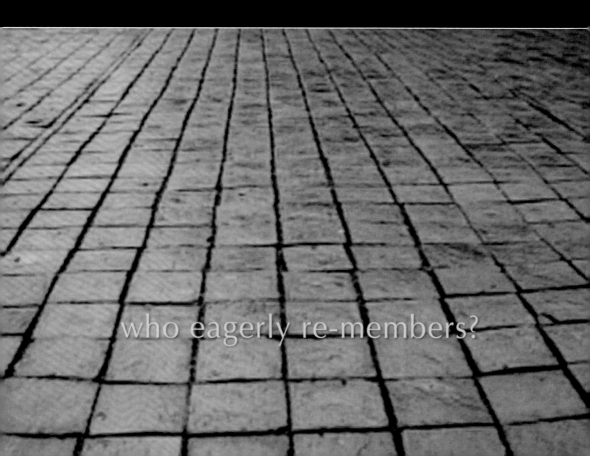

who eagerly re-members?

dimension of experiencing love. And what is retained from the poem are only those instances that highlight the "scents of a narrative"—here, as I have it, the conflicted loyalties and the nonconforming choices of the woman protagonist who, despite her sacrifice and impeccable ethics in love, does not fit squarely into patriarchal norms and ideology.

In other words, when I approach culture, what appeals to me is not the search for "a good story," the individual story, or the clear message that marks our consumerist society's media productions. The ubiquitous demand for a centralized story sets the mold for funding and exhibition networks whose criteria for what is "good" and "clear" serve to promote a monolithic, domination-subordination mode of storytelling. What appeals to me, however, is a making that maintains at its core a relation to infinity: a focus that is vast in scope yet specific to the culture observed; situations that pertain to local people and at the same time speak to those from elsewhere; women whose peculiar conditions do not merely represent those of their peers—in this case, Vietnamese women. So when people say, "It's a film on Vietnamese women," I would say, yes, *but* . . . For example, I remember well when I presented and showed *Surname Viet* in Bologna in Italy, some women from the audience told me how moved they were by what they had heard in the film. They felt that it was their own condition that was being addressed. And this, I was told, also occurred with a group of Palestinian women who discussed my book *Woman, Native, Other*. So when you choose something specific it could be at the same time locally precise and very wide in scope.

LM

Let me linger a little bit on this question of the "name," and the paradox that in order to deconstruct or undo the idea of a specific place or nation-state you have to reassert its name. For instance, in a lot of these films you name "Vietnam" in the title.

In *Reassemblage*, you narrate that someone asked you: "You want to make a film on Senegal, but *what* in Senegal?" A signifier of a nation-state seems to be very important both as the locus of a de-figuration and, at the same time, a locus of play.

TMH Absolutely. It tells us something about our compartmentalized world—how knowledge is forcibly compartmentalized for control purposes, and how, even with the constant talk about virtual boundlessness in globalization, the world we live in is a world of proliferating fences and walls. Boundaries are all over in our language, in the way we relate to people and events in life. In remote villages of West Africa, where lived "Africa" is not divided into nations, people identify mainly in terms of genealogy, ethnicity, and linguistic belonging, and it's not at all uncommon for these villagers to speak four to six African languages. In other words, they are fluent across geographical and ethnic borders. They speak the languages of their neighbors in addition to their native language and the trade language of their region. So the system of the nation-state and its derivative notion of nationalism remain quite disconnected, at odds with this cultural context—something like an exogenous imposition, a hard line drawn over the map of precolonial African kingdoms.

Such a structure of governance taken for granted as the norm is not unrelated to the way we consume film in general. In a story-driven approach to documentary, for example, it is often thought that if you cover a subject, you have to focus on a specific topic, a "case study"—something finite like an individual's story, a conflict, a ceremony, an incidence within a village or a community, or else a family drama—but if you are focusing on everyday life, building on the gestures of a culture via ordinary activities, and composing a distinct tapestry of sense, sight, and sound as you go, it doesn't seem like

a subject for a number of film consumers, especially film programmers and funders, who always ask for "a story" (obviously, not the kind of cosmic, spiritual Indigenous storytelling whose scope reaches across generations, which I discussed in *Woman, Native, Other*). So even when you make a documentary, they beg you to develop an individualist, character-bound story with a beginning, middle, and end, abiding by the normative theatrical three-act structure and its conflict-driven climax. For me, filmmaking is not at all about stories or messages. Those come along, but they can't define cinema.

Why not approach filmically a country, a people, a culture by starting with what comes with an image (mental, material, digital) or with a name like "Vietnam," "China," "Japan," or "Senegal," for example—as explicitly asked in my earlier film *Reassemblage*. What exactly stands for, characterizes, and speaks to a cultural and political event? Through the specific apparatus of film and video, how does one show, tell, and receive while refusing merely to represent? In other words, the given name or the recorded sound image is a site of departure, where one takes off rather than arrives.

The focus here is on the play between seeing and not seeing; on the work of the invisible within the visible, and vice versa; or else, on how the seen both displays and veils, and how what is necessarily left unseen in each instance of the seen could contribute to bringing about *another seeing*. Questioning the prevailing claim to visibility, such a seeing acknowledges its limits while inducing one to *see anew*, not only with eyes wide open, but also with eyes wide shut. Of course, this is only one way of questioning the established tendency to reduce reality to the realm of the visible. Another way would be to address the other senses involved, since cinema is not a mere art for the eye but an experience of the whole body.

LM

I was struck by the multiple facets and ambivalence of the title, *Forgetting Vietnam*. So, with "forgetting"

you highlight the act by which one might attempt to forget, the paradox of acting the forgetting, and you give us this beautiful quotation: "To really forget, we must fully know what we want to forget. . . . But how to remember the face of a war?" (Phạm Tiến Duật). This runs against the idea of a *devoir de mémoire*, in the sense of memorialization. Indeed, it inverts it: what's at stake is not a determinate form of remembrance, as in Walter Benjamin's idea of the Proustian image, but a determinate forgetting. So, I'm interested in how you treat memory and forgetting via image and sound.

TMH This follows nicely from the earlier discussion concerning the land-water pair *đất nước* that defines Vietnam as a country. A common place to start would be to say: land records, water dissolves. The forces of preservation and oblivion go hand in hand. As stated at the beginning of *Forgetting Vietnam*, "It all begins with Two." Nonbinary pairs multiply in unexpected courses, and there are always at least two ways to enter my films.

 To return differently to what I said about my three films on Vietnam being very distinct from one another, *Surname Viet Given Name Nam* is a 16mm film in which the stories of women interviewed in Vietnam by a French-based Vietnamese writer, Mai Thu Vân, were first translated and published in French, then retranslated by myself into English and made into a "script" for the film. Through the condition of women both in Vietnam and in the diaspora, the work features the historical multinaming of a country and the politics of translation and interview—or documentary's antiquated devices.

Shot in 35mm, *A Tale of Love* deals with the genre commonly called "fiction" or "narrative feature," in which the love story is requisite. With the love story comes a whole process of voyeurism, for every story of love on-screen is a story of voyeurism. The more of a voyeur you are in a feature narrative, the more intimate the view you offer to the spectator, right? So the camera would follow people everywhere. In their bathroom, in their shower, in their bed, in their nudity, but also in their terminal illness, in their hunger, in their suffering. It is an extreme form of voyeurism, which I literally and provocatively exposed and incorporated into the role of one of the main characters of the film: the photographer. *A Tale of Love* is structured in such a way as to give you at first the feeling that you have a story, but as the film moves on, the story seems to disappear. As it loses its linearity and is made to dissolve, the viewer is invited to follow the narrative threads the way a deer would track a scent. "Narrative, in her world, is a track of scents passed on from lover to lover," says a character in the film.

In *Forgetting Vietnam*, I was dealing with footage shot in 1995, with the advent of Hi8 video, and footage shot in 2012, with the advent of High Definition (HD) video. So you have low and high technology, tradition and modernity, rural and urban, and it's arduous to make them work together. Like other Third World countries, this is a problem that Vietnam is struggling with, not only because the leap required to bridge the gap between old and new is much more abrupt than in European countries, but also because the concept regulating the relation between low tech and high tech in today's consumer society is *incompatibility*. Everything is linearly made incompatible between past and present, North and South, East and West, so that we are constantly compelled to keep on consuming in our throwaway society.

The three films are therefore different from one another in their treatment, approach, and concerns, even though this may escape many viewers. It's interesting to see how curators tend to program them. They usually put my African films on

the same bill, and my two last Vietnam films would often be screened in consecutive order, one after the other with barely a break in between; and that's because they go by subject. But if, instead of content, they were to go by cinematic concerns, they wouldn't program them together. For me, lumping them together would make it impossible for the viewer to open up and take in their autonomy and integrity as film.

I mention all this to give you the wider context required to respond to your question about the complex relation between forgetting and remembering. In the making of *Forgetting Vietnam*, one of the commitments I kept in relation to war images was the following: most of the films made on the war in Vietnam show you the horrors of war mainly through what constitutes the sensational in cinema. So: explosions, bombings, killings, bodies, buildings and environment being burned, mutilated, and blasted; violent, bloody scenes with wounds oozing open (blood as depicted in mainstream films is cheap); and then suffering that is strident—noisy and loud. Such a depiction of war amply exploited on-screen for spectacular effect is something that I do not want at all to have in my films. Showing brutality has its journalistic function, but violence for violence's sake is how the media continue to desensitize human suffering and distress, as well as how the entertainment industry claims to serve a consumer society steeped in violent media.

And then you have the other kinds of films evolving from this war, of which you really have to ask: Whose interest does it serve? For most of the time, what's covertly at stake are American interests. Whether their politics are liberal or conservative, mainstream films made in the name of the war in Vietnam speak to one side of the war and contribute to sustaining American hegemony. So, sometimes during one of these films' screenings, I would be sitting in the audience with other Vietnamese people, and they would look at me and say: "Do you think it has anything to do with us?" [*Laughter.*]

With *Forgetting Vietnam*, viewers often wonder why there are no images of the war, but the war is all over, whether visible or otherwise. Its traces are everywhere, present in the environment, in people's memory, in their speech and daily rituals. For example, the poets quoted in the film are mostly young—those whose generation has not known the war. Yet their thoughts and feelings are full of it, like this young woman poet, Phan Huyền Thư, who, writing about Huế—the ancient imperial city in central Vietnam whose traumatized inhabitants silently endured the mass killings perpetrated during the historical Offensive of Tết Mậu Thân 1968—would disclose her sentiments as follows: "I want to murmur to Huế and to caress it / But I'm afraid to touch the sensitive spot on Vietnam's body."

The war's affect still runs deep within the young generations born after it or at its end. On the surface, everything seems to have returned to normalcy today, and ironically, in the current era of terror, Vietnam is reportedly one of the safest places to travel to. But the war is all-permeating, very present in its absence, and not just present the way the media represents it. The commitment to not use any footage of the war that has been taken and circulated through the media in *Forgetting Vietnam* was a question both of ethics and of intense remembering in forgetting. In *Surname Viet Given Name Nam* I deliberately used some archival footage of the refugees in the 1950s with the stories of refugees in the late 1970s and 1980s so as to remember rape as a national and yet gender-specific problem across times of war. But in *Forgetting Vietnam*, I didn't want any war footage because as soon as you have "Vietnam" in a film, people would expect to see these kind of images, and when these are not there, they feel somehow lost, as if Vietnam as a war is the only way they could relate to the country. So this is one way of forgetting.

Another more obvious way to forget could be seen in what has happened with tourism since the end of the war. There are many American soldiers who traveled there, not so much to remember Vietnam as to forget the Vietnam they knew, which

is partly understandable. They are likely interested in returning to learn about the country of which they knew so little when they first came, deluded by their might, to eradicate an enemy force via military power. However, there is also a nostalgic side to it. They return to their battlefields, but this time as a tourist, as a consumer, so of course the Vietnamese folks would immediately oblige. Today, in the flourishing industry of war tourism, the complex interwoven tunnel system in southern Vietnam, which bears witness to the guerrillas' unmatched ingenuity and endurance, has become a source of investment. The multilevel subterranean structure that allowed the Vietnamese to gain victory over the Americans is precisely now part of the exoticism of war in the tropics, and the very place for touristic . . .

LM You can even shoot a gun, right, you can shoot a gun as part of the experience?

TMH It's incredible. That's a second aspect of the forgetting. This being said, what is equally important to me is that when you go to a place with a camera, you rely on the camera to remember for you. And with new technologies—the iPhone being a popular example—you can select, delete, trash, edit, collect, keep whatever you want. This is how memory is treated today through digital technology. The difference between old and new technology is all about systems of memory. However, when I don't have a camera I remember very intensely the experience of an event, a place, a culture, a people. Relying on the camera to capture and record has led people to think that they can preserve memories with a camera. But actually, what they preserve is of a different nature than what they experience and remember. In that sense, one can talk about a "memory for forgetfulness," since forgetting here means engaging critically with the world of cameras' and iPhones' ever-faster memory. Show, tell, record. On the one hand, such an unquestioned economy of display-so-as-to-remember

should be problematized in relation to everyday practices of forgetfulness and to Indigenous economies of preservation-through-burial, for example. On the other hand, the more you attempt to forget and evade what you try to forget, the more it comes back to haunt you. Vietnam's specter still haunts the White House, as it has the world at large. The question of remembering and forgetfulness could never be separated. For me, it remains a nonbinary pair, two faces of the same coin.

LM I would like to discuss the problem of heroism because it appears to stretch all the way back in your work to *Love-cidal: Walking with the Disappeared*, which articulates a critique of the heroic version of war, war seen in terms of victory vs. defeat. The discourse on heroism seems to lock memory on every side. Memory is locked by the discourses of victory—that is, in the official Vietnamese discourses of history and state—as well as in a left-wing discourse which maintains a melancholic relationship to that moment, with its strong internationalist commitment against the war that hasn't since achieved comparable momentum. In the US, you also have the two sides of, if you will, "defeat": the Vietnamese diaspora for whom it is still difficult to speak about the war now, as well as the American veterans' side.

TMH Your take on heroism in this context is pertinent, and I can see the link with *Surname Viet Given Name Nam*, in which

the women interviewed criticize the way they were presented by the foreign media, that is, always as "heroic fighters." In *Forgetting Vietnam* and especially in my last book, *Lovecidal*, it is the victory mindset that I see regulating war, paradoxically bringing together the two warring sides. It is a mindset that divides the world into winners and losers. When you think about it, it is absurd to always want to be the winner and to always consider the other to be the loser. Heroism righteously trotted out to disavow suffering and distress partakes in such inanity. In today's "new wars" it might be more appropriate to say that the line between winning and losing has been so muddled that there is no longer a loser. Every war champion claims victory at all cost, and hence, battles are only fought between victor and victor.

For example, one of the most striking and puzzling moments for me during the 1991 Gulf War was when the Americans were declaring victory over Iraq. As television screens were filled with talk about the war coming to an end, thanks to the glorious results of Operation Desert Storm and the swift victory by American-led coalition forces, we, earnest spectators, were briefly shown images of Iraqis celebrating their own "victory." This is what in *Lovecidal* I call the "Twin Victories." Of course, for Western media reporters, it was mind-boggling to see such a celebration when Iraq had lost the war. Everyone said at the time that Saddam Hussein was deceiving his people. For me, it's not the same concept of victory. Same word, similar striving, but not the same thing. The West is always probing and measuring the other in their terms, but it would be more relevant to ask seriously why Iraq claimed victory where the Western world only saw defeat. As with the Algerian or the Vietnam wars, the West may obtain military victory temporarily via a power from the sky, but nations of lesser means ultimately gain political victory via a power from the underground. These persist through elaborate subterranean structures built to fight those who claim to see everything from the sky.

Victory can also be a victory like 9/11. Who is winning? Who is losing? Such senseless questions evade the full significance of war. There is political victory, there is symbolic victory, and then there is this victory achieved by force of arms, which ultimately serves the military empire, allowing those considered all-powerful to prevail over those fighting through guerrilla means. It is this imbalance of asymmetrical warfare and the rise of singular forms of everyday resistance that I raised in *Lovecidal*. Not only do they speak to the absurdity of war, they carry the potential to change the landscape of struggles for justice.

In the war against the French, the moment I focused on was also the moment of victory and defeat at Điện Biên Phủ —that memorable closing instance when a Viet Minh combatant asked the French colonel, *in French*, "*C'est fini?*" and the officer replied, "*Oui, c'est fini.*" It's like hearing two children play-fighting and then turning to one another as they end the game: "Is it over?" "Yes, time's up." War comes down to something so infantile, so insignificant. You lose so many lives just for that moment of victory. Together with the affective dimension of war, this is the absurdity that I wanted to highlight. The same thing goes with the so-called end of the war in Iraq. The Americans' exit strategy was to pull out during the night so that you couldn't see their withdrawal. Then they continued the war through means that were not explicitly martial, but were fed by their military-industrial complex: arms industries promoting not only the circulation of American weapons, but also private security contractors and more.

It is interesting that you link heroism to memory in the context of state discourse (the official voice of Vietnam) as well as left-wing discourse. The orthodox Left could not hear women speaking critically within their midst; it could not tolerate the complex positioning of Mai Thu Vân, whose interviews I adapted for *Surname Viet Given Name Nam*. She's a well-informed Marxist herself, but her book

was shunned by Leftists because she exposed the shortcomings of the system through the voices of women—from both North and South—who dared express their discontent and call into doubt the Party's patriarchal structures and State feminism. Of course, the absurd question that arises in these cases is: Who is more Marxist than whom? Is *her* stance more Marxist, because she is critical and she remains true to these heroic fighters' voices? Or is it the oblivious dogmatic Left that can just unfold its own narrative, without having to involve themselves in the struggle of women throughout history and his-story (history by and for men)?

LM

If you don't mind, as we are currently celebrating the fiftieth anniversary of 1968, I would be interested in shifting this reflection back in time. I'm thinking of two works that were made around '68 on the Vietnam War that explicitly tackled the issue of heroism. Firstly, the film *Loin du Vietnam (Far from Vietnam)* (1967)—collectively realized by Joris Ivens, William Klein, Claude Lelouch, Chris Marker, Alain Resnais, Agnès Varda, and Jean-Luc Godard—a film in which, in a striking scene, Bernard Fresson monologues to a completely silent Karen Blanguernon about the heroism of the Vietnamese people, the rightness of their cause, and the impossibility of living with the idea that he cannot prove his own heroism. The problem of being "far" from Vietnam, which Godard develops. Secondly, Susan Sontag's text "Trip to Hanoi" (1969), in which she

spends a good half of her narrative complaining that her trip is a sort of anticlimax because she was expecting to see a heroic people in action and is disappointed. They are living a great destiny but they don't seem quite to grasp what is happening to them. . . . And the tension is very much about communication; she finds it really hard to communicate with them. In the end she reconciles herself with her ideal and she ends on a praise of their "laconic," "flat" form of communication as a model of "economy of words." In your own trajectory, how did you react to these kinds of engagements with the Vietnam War?

TMH We're not dealing here with Left versus Right, but rather with a left within the Left, with the issue of gender looming large. This fight is much more challenging. Sometimes we speak the same language, and yet we feel as if we were dispossessed of the very tools that enable us to have a voice. The rhetoric of equality and justice is readily appropriated by the Left's "old boys' club," which is why the "linguistic self" (Gloria Anzaldúa), the "verbal struggle" (Mao), and the politics of representation continue to be fought on the feminist front.

When I made *Surname Viet*, I did initially get hostile reactions from both the Left and the Right. But the more vicious ones were from the Left, not from so-called rednecks as one might expect, but from righteous people who didn't want to hear any of the views put forth in the film: partly, it seems, because women didn't really count and their voices didn't score with theirs; partly because the history of the war in Vietnam is a territory they authoritatively owned and

controlled. The only thing they would hear was that the Communist Party was criticized, which they immediately interpreted as a stance against the revolution and socialist Vietnam, which was not at all the point. There was no room in their mind for difference, only for opposition. A film on the plight and suffering of women in the war is commonly viewed as being partial, but it doesn't seem to cross many viewers' minds to regard as biased and chauvinist all the films made on the war, which almost exclusively feature male anguish and male heroism.

In the aftermath of Vietnam's victory, many people who fought dearly for socialist Vietnam couldn't voice their thoughts. They spoke almost as if they were muzzled. You couldn't speak unless you did so about the fatherland in positive terms. Even sadness and mourning were state-mediated; it took decades of struggle for writers in Vietnam to concede with quiet laughter that they have at long last "gained permission to be sad" and "can now weep without being gagged." I'm thinking here of the wonderful writer, archivist, and translator Phạm Thị Hoài, whose novel *The Crystal Messenger* (1988) was banned in Vietnam, and who is now living in Berlin. During wartime she was an enthusiastic revolutionary of North Vietnam and yet she has come around since then to asking aloud the question: What happened to that revolutionary spirit? What is left from that revolution?

This is where we can situate my response to a work like *Loin du Vietnam*. I don't want to comment too much on Susan Sontag because the kind of expectation she had for "a heroic people" in action could, at best, be qualified as naive and, at worst, as arrogant in its paternalism. This is the tension around communication, which is somewhat similar to the early situation of feminism, or should I specify "white feminism," in which the fight for "women" excluded or barely acknowledged the plight and contributions of women of color. So in its exclusive claim for equality, "woman" could remain oppositional and discriminatory from within. Going to Vietnam with a superiority complex and a preconceived

idea of what the revolution should look like, and expecting communication with the locals to be readily friendly and forward to an American foreigner, is much less interesting to pay attention to because, as an attitude, it is highly patronizing.

But Godard is an interesting case. Although *Loin du Vietnam* is a collective work that seemed to be put together quite expeditiously, it was an activist gesture of support. The short section titled "Camera Eye" that Godard contributed, appearing on-screen with his camera—lens and apparatus—was quite to the point. Unlike some of the other sections that endorse unquestioningly the norms of reportage (omniscient voice-over running throughout the footage, in which the relation between the verbal and the visual was not thought through), Godard's section critically deals with the core of reportage. For this kind of eyewitness genre, being present and shooting on-site is essential. But Godard told us from the outset that he was denied permission to go to Vietnam to shoot, and he accepted the North Vietnamese government's refusal because, as he interpreted it, his politics were rather vague and perhaps what he would come up with might do more harm than good for their cause. Rather than abandon the project, however, he offered a work that spoke to his being "far from Vietnam." Such a position has disadvantages, but it could open up a wealth of possibilities such as acknowledging that "Vietnam is in us" and that one should create three or four Vietnams . . .

More generally speaking, and just like with the film Godard made on the Palestinian struggle, *Ici et ailleurs* (*Here and Elsewhere*), whatever he is critical of, he is right in the midst of it. He is reckless in the way he attacks and exposes himself as a film director. The criticism is not pointed outward, it is pointed right at himself. Sometimes what he offers can be offensive, but it is actually offensive—with him right in the middle of the picture, so to speak. For me this is far more dangerously challenging than the position in which criticism is voiced from a safe place, as if what one points to is outside,

external to oneself and to where one stands. As I just mentioned, Godard actually put to use the government's rejection to assume his position as outsider and his being genuinely "far from Vietnam." He is not claiming to speak and show from "inside" Vietnam. When I came up with the title "Forgetting Vietnam," I was staying away from the righteous, moralistic connotation of one like "Remember Vietnam." With all the wars going on today, the White House is not remembering well. Every time war looms, the specter of Vietnam haunts the president's speeches, even though he may assert that no, this is not its repetition. But the mere fact that its name repeatedly crops up means that the specter of the Vietnam War still walks the halls of the White House.

Contextually, Godard is explicit in his positioning. He is far from Vietnam. In *Ici et ailleurs* he makes us smile and cringe at the kind of grandiose speech that struggles of liberation and socialist regimes are so fond of, and with that the grandiose notion of heroism. It's discomforting to listen to grandiosity in its in-progress construct: militant speech coming out of a child's mouth innocently performed with pompous gestures, its being awkwardly rehearsed by a woman on-screen.

LM

It seems to me that with this question we are really in the midst of your own research into another way of relating to politics. Do you feel that the critique of anthropology and ethnography that you were leading in the early 1980s is still current? Is it still urgent for you? Or has it lost some of its urgency?

TMH

Well, the first thing to recall is the link between anthropology and colonialism. Anthropology has done a lot to disengage itself from the fact that it was born with Europe's colonial

return

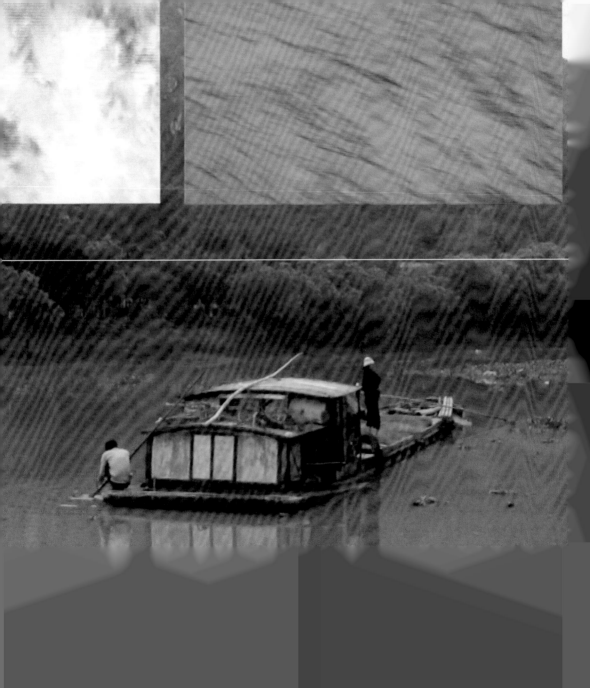

expansions, but in its pseudo-scientific claims anthropology remains steeped in a colonial ethos. The questioning of the anthropological apparatus and its essentializing constructs was urgent when I was living in Senegal and doing research in West Africa. It was not as if I didn't encounter such a colonialism-inflected discourse in Vietnam, but I was very young at the time and was not as puzzled as I had been in Senegal by a discourse that turned you into an "other." What was so baffling for me in Senegal was not just the white administration or the white anthropologists and researchers who carried on this colonial structure of the mind, but actually the insiders themselves, African intellectuals and city dwellers who often enacted the anthropologist's mindset in speaking authoritatively about their own culture. So at the time it was urgent for me, especially when making the film *Reassemblage*.

I've moved on since, and today when some viewers tell me they find my films to be "ethnographic," I take it positively, especially when coming from an ethnographer. You can be ethnographic without making an ethnographic film, not because you adopt a process recognized or approved by anthropology, but because of the rigor you bring into your work when you look at another culture. Having learnt to see anthropology through my studies and research in ethnomusicology, I think anthropology is at its best when it acknowledges the crisis at the core of its being, and when it assumes the precariousness of its status, rather than evading or denying this by trying to institute its authority. It is a vulnerable field because you are trying to do research in a context that is unfamiliar to you, and then trying to share it, to translate it to another context. You are constantly in the position of mediator and translator. If one recognizes the impossibility of the task of translation (the way Walter Benjamin discusses it) and the impossibility of translation in one's work, it becomes an interesting work—one that is situated at the edge of being no longer valid. Offering something valuable while questioning its validation is a way of de-positioning

while positioning. So that's where anthropology could be at its best. And I do find a small number of scholars and young people working in that direction today.

LM
 In order to bring the different threads
 of our conversation together, I'd like
 to ask you to say a bit more on the
 way in which you reflect on 1968 today,
 and in relation to the Vietnam War?

TMH There are many ways to answer such a vast question. I'll give it
 a try, first by drawing on the context of our discussion, taking
 Vietnam as an example to relate to the revolutionary spirit
 of that transnational moment. On the one hand, as stated
 in *Forgetting Vietnam*, "Can one simply place the war in a
 museum?" Through what is made visible and put on display
 for memory, what precisely is kept invisible and erased from
 memory? In other words, how to remember the historical
 "defeat" of '68's emancipatory ideas so as to keep their legacy
 alive in today's so-called free-market ideology (a mere alias for
 corporate greed)?
 For example, in Vietnam, 1968 was the memorable year
 when the Offensive of Tết Mậu Thân was launched. The mes-
 sage which informed North Vietnamese forces that they were
 about to inaugurate the largest campaign of surprise attacks
 against South Vietnam's military and civilian control centers
 was relevant enough: "Crack the sky, shake the earth." In its
 zealous mission of liberation, Hanoi firmly believed that the
 Offensive would trigger a spontaneous, supportive uprising
 of the population, which would lead to a quick, sweeping vic-
 tory. But the outcome of the Offensive was far from what was
 expected: the loss of lives—mainly civilians, but also troops
 from both sides of the battle—was staggering. Nonetheless, the
 failure to achieve their main objective of spurring uprisings
 throughout the South was still translated into a victory for
 the North, as the media's coverage of the atrocities and the

extent of these human losses during the Offensive exposed the truth of war in all its messiness and changed the American public's perception of their role in Vietnam.

Today, the 1968 Huế carnage allegedly perpetrated by the National Liberation Front during their occupation, as well as by America's firepower in their resolution to recapture the city, remains a "most sensitive case." On the one hand, placed into oblivion in the official version of war history and conveniently absented from the government-operated War Remnants Museum in Ho Chi Minh City. On the other, persisting in people's collective memory, thereby revealing the utter delusion of war, when to win and regain control means to destroy what one set out to protect. In this bitter lesson of war, victory in defeat for the Northern forces was followed by defeat in victory for the Southern forces and the US. As stated in the film, no matter how carefully selective memory is in rewriting history, the "scars of war have surfaced publicly." The survivors' harrowing testimonies as well as the mass graves discovered in and around the city, which revealed victims buried alive in addition to those clubbed or shot dead, have had a massive impact on the 1975 refugee exodus. They have also triggered the exodus of human remains since the 1990s. The war's many faces cannot be reduced nor simply buried.

Must victory thrive on selective forgetfulness and the erasure of its defeats? The socialist Vietnamese government has never acknowledged the slow but unprecedented exodus of "boat people" and refugees—some two million persons by 2001—who continued to leave Vietnam following the war's end. As Phạm Thị Hoài remarked, "It took the winners ten years to realize that victory was not something that could be eaten . . . It took the US twenty years to sign a peace treaty with its own past." Her analysis also informed how the war provided the Communist Party with justifications to fight and rule with "the mandate of Heaven"—a principle borrowed from China whose legitimacy must constantly be reified and

deified. This is how the war heroes' monopolizing authority and the war-military leadership, turned now into totalitarian control, continue to thrive.

Decades after the Vietnam War, the foundational cultural values of the revolutionary cause have lost their validity and the consecrated ideas of communist ideology have become a farce—blatantly betrayed, at best relegated to die-hard nostalgia. Social inequality has increased at full speed. To give you an example of the Vietnamese flavor of state capitalism today: while foreigners talk avidly about a booming real estate market and the new Housing Law which allows them to invest in Vietnamese property, to the consternation of Los Angeles' South Vietnamese diaspora, the upper echelons of *socialist* Vietnam's ruling class are buying up luxury properties in Orange County and elsewhere in the US. When this crony class comes to America for a visit, they reportedly bring regiments of house servants, moving in *with style*.

Whose victory is it? This is a question one could also ask in relation to the '68 of the West and the rest of the world, whose notions of "revolution" have since been so hollowed out by racial, sexual, and fiscal backlash that rather than radically changing, for one, America, the old values have been comprehensively reiterated. With the "alt-white" effect and the dire political situation in the US today, the country continues at core to be a "nation at war"—not only abroad, but also, more destructively, at home. We are undergoing a virulent revival of the old orthodoxy. There's no voice of reason, no discursive logic, no psychiatric name-calling that could be effectively used in response to the kind of belligerently segregationist rhetoric coming from the Oval Office and its alt-right mouthpieces, which is tearing the country apart and letting loose all forms of bigotry and human debasement in social relations.

What happened to "the revolution of values," which Martin Luther King Jr. used to dream of, during which the established political and cultural institutions lost their

legitimacy, and patriarchal colonial systems came under attack, triggering the decline of Western hegemony? In the present climate of disappearing ethics, of an unbridled revival of sexism, racism, homophobia, xenophobia, and Islamophobia, to mention a few examples, America's heartsick society is suffering a huge throwback to its past. However, to acknowledge this state of things is not to assume a defeatist stance. As I discussed in *Lovecidal*, the transgressive phenomenon of women marching across nations in their struggles for justice has now amplified in scope to become the Women's March, built on diverse alliances around the world. Highlighting a different focus each year, it contributes to changing the way people take up political action as they become aware of their agency as political and social actors.

This interview took place in December 2017 for the London premiere of *Forgetting Vietnam* at the Tate Modern, programmed in parallel with a full retrospective of Trinh's films at the Institute of Contemporary Arts, London. It was first published in the December 2018 issue of *Radical Philosophy* with the following introduction by Lucie Kim-Chi Mercier:

"Since the early 1980s, Trinh T. Minh-ha has developed a complex theoretical, visual and poetic response to the implicit politics regulating the production of discourses and images of cultural difference. Working through the multidimensional effects of imperialism and neo-colonial modernity, her works played a pivotal role in the emergence of postcolonial theory and critique. Her now canonical 1989 book, *Woman, Native, Other*, investigates the contradictory imperatives faced by an 'I' positioned 'in difference' as a 'Third World woman' in the act of writing, as well as in critiquing the roles of the creator, intellectual and anthropologist. But aside from the critique of mechanisms of cultural representations, Trinh's works experiment with deconstructive and transgressive ways of questioning their own classifications. They play on, with and across cultural and national boundaries. Alongside films and installations, Trinh has published numerous essays and books on cinema, cultural politics, feminism and the arts."

IN THE REALM OF SILENCE

Conversation with Xiaolu Guo

Xiaolu Guo (XG)

Though it's your first digital film, I find such persistent, shared qualities between *The Fourth Dimension* (2001) and the first film you shot in Senegal, *Reassemblage*, particularly in your aim to speak "nearby" and not "about" the culture that you are portraying. What has changed, or what has not, in your film practice since *Reassemblage*?

TMH

The question of change or sameness is a little bit—to use terms of cinema—like stillness and movement. If we think of them as opposites, then we think, for example, of stillness as something that is rather stale, that does not change or move;

and we think of movement as something that brings about change, that constantly renews itself.

For me, they are like two facets of the same coin. In stillness you can have full speed just like what video and digital technologies offer us, and in movement sometimes we appear as busy bodies, but actually we are stamping ground, staying in the same place. So it's not a question for me of changing or having something different. Change is always there.

Each of the films that I have made involves different encounters. For example, in *Naked Spaces*, I journeyed across six countries of West Africa. In *Shoot for the Contents* (1991), I was venturing in China. And of course in *Surname Viet Given Name Nam*, I was looking at something we could maybe call my own culture.

The more you look inside it, the wider it gets—so what you think of as Vietnamese is not so Vietnamese after all, because the boundaries are constantly morphing. And with this we come to a film like *The Fourth Dimension*, and the encounter with Japanese culture.

In this encounter, am I an insider or am I an outsider? Asian cultures have a lot of inter-crossroads and similarities, but in terms of living in Japan—no matter how much you try to blend in, the outsider is an outsider.

XG

I also want to ask you about your relation with your camera. In those films—including your fiction film *A Tale of Love*—there is this uncertainty in the way the camera is operated that I find very interesting. You might pan the camera toward the left and we expect to find something extraordinary there, and yet there's a hesitation and you pan back.

In *The Fourth Dimension* I think your camera is much more

certain than in your earlier films. But still you're not hiding the processes of zooming, panning, moving, and trying to find your subject through one keen eye—so your process of filmmaking is completely visible for your audience, and in a way the audience might feel as if they are operating the camera themselves. Can you talk about this?

TMH It's wonderful you have this feeling that you are operating the camera when you look at the film. The panning never goes from one specific point to another, which is what cinematographers usually rehearse at length so that they can give you a gesture that is impeccably confident.

In my case, it's the panning itself that is most important, so if you hesitate, it's your body movement that is manifested through the camera. In that sense it's not about going from one end point to another end point; it's everything that happens in between that's important.

When you pan, it's not as if what's in front of you is interesting—but the mere fact that you frame and you pan gives it full charge and intensity, so we look at it because the camera is capturing it.

The camera used in Africa was a 16mm that is often on a tripod or sometimes handheld, but in *The Fourth Dimension* I was using a palm-sized handheld camera, and you can tell the movement is very different.

XG I'm of the generation that never shot film through a film camera. Shooting digital all my life has been both a blessing and a curse in a way; but you are of a generation that has had the privilege to use film cameras until

suddenly you could use digital. How do you feel about this in terms of visual quality and your own relation to the camera?

TMH In terms of relation to the camera or to film in general, when you work with film there's no immediate gratification. You actually go through many phases and steps, whereas in video it's very intense because it's almost as if all of those phases are collapsed into one moment. So that's why, when I turned to digital technology, I had to deal with time.

To bring back Deleuze's three types of cinematic images—perception, affection, action—in the movement-image, and the difference he made between a cinema based on movement (movement-image) and a cinema based on time (time-image), I would say that all of my films are time-films.

The intensity of time and how we experience it is precisely what digital technology gave us. That's why I talk about speed in stillness. It's that kind of time.

XG It really reminds me of Godard's *Goodbye to Language* (2014), and the intensity of the digital in his language that we're not used to; and also the vast transition between images and the video quality that he reinforced. I think that's what we feel in *The Fourth Dimension*, too. You made three digital films, but all of your other films are on film, no?

TMH Yes. All the films before this one are 16mm or 35mm films.

XG Another thing I'm very curious about is your intellectual heritage, or journey. You left Vietnam when you

were seventeen, during the Vietnam War, and went to Illinois in the US, where you studied music and literature.

While writing your PhD dissertation, you also left to study ethnomusicology in Paris, and then later on began your film career in West Africa recording tribal music and dancing in the 1980s.

This is extremely unusual, especially when comparing your practice with that of Chris Marker or Jean Rouch, who came to China to record "the other" or "the otherness," away from Eurocentric culture. For me, it's a mystery how you operate with your own Vietnamese cultural heritage alongside the Western influence on your eyes and educated mind. Can you talk about this?

TMH When *Reassemblage* first came out, the Asian American communities were really not happy with it. They were very critical, and I often got the question: "Why don't you make a film about our people, rather than go to Africa?"

Even today, I think many Asian viewers still have that question, and I think it's fine but in a sense I didn't calculate it. It just happened that when I was studying in the US, I was mainly sitting with international and African American students, which led me to a very different path.

Also, the desire was not to stay in the US to find a job or go to France. I wanted to go somewhere else, and this was when Africa was suggested to me by my friends. But after I made two films in Africa, and I turned around and made *Surname Viet Given Name Nam*, it seems like the Asian American

community was a little bit happier with that situation. But for a very long time it was difficult.

XG

Also, I guess there was a moment when feminist theory was coming to you, or you moved toward it. I remember I was studying at the Beijing Film Academy when I first saw *Surname Viet Given Name Nam*, but they didn't have *Reassemblage*, which might have been because of the nudity that it contains—there's still censorship in the Beijing Film Academy.

When I came to the UK and studied at the National Film School and saw your African films, it was a huge revelation for me in terms of what you were thinking and how you became who you are as an artist.

I really appreciate those famous words of yours concerning your intention to "speak nearby" and not "speak about" culture. I think that's an extremely different view from the male-centric judgment of culture— you have this position that is very clear, beautiful, and fresh.

I want to quote you here, from your book *Cinema Interval* (1999), where you say that "most documentaries on Third World countries exist to propagate a first world, subjective truth."

You also mention your American-centric anthropologist world and the so-called experts of other cultures,

saying that "they are so busy defending the discipline, the institution, and the specialized knowledge it produces that what they have to say on works like mine only tells us about themselves."

Can you tell us about the difficulties that you've experienced as a writer and filmmaker in that world, over the years?

TMH Well, I think that if I've come to the point of saying things like that, it's also thanks to the hostility that my work received at the beginning. The first screening of *Reassemblage* at the 1983 Flaherty Film Seminar actually provoked such hostility in the audience, but fortunately for me, every time there is strong hostility, there is also strong defense.

So the audience was divided in two. At the time I had just come back from Senegal, and even though I knew the film was critical of the way anthropological films were made, I did not expect that audience to be right in front of me at the seminar. It was a very intense situation, and because of the continuous blows from one kind of audience to another, I have had to talk about the film lucidly.

This is not my way, because the films I make invite accidents, incidents; things that you have never thought of before, that resonate among themselves. It's about how you let the material come to you, how you do not simply impose a kind of subjectivity on the image, how you work with emptiness, how you work with the voice—all of this.

Because of the compartmentalization of knowledge and the claim to expertise that keeps bringing up these divisions, one has to speak about one's work in a very lucid way. These are some of the difficulties. The way one speaks about one's work—even when you talk about your own work, you don't indicate to people, "This is what it is all about." But you speak

close to it, so it's the same kind of challenge as when you make the film.

XG Regarding your editing process, sometimes you create sound holes by cutting the sound off completely so that there is total silence, and then you might return to a completely different soundtrack.

The audience might be able to bear that kind of editing in a fiction film, but they sometimes cannot bear it in a documentary film, because it's supposed to be recording reality. I think this is a challenge to the traditional audience, and it really suggests the different ways of making film and the ideas that surround documentaries.

TMH I don't do that to bother the audience. For me, it's about your relation to silence. There are many kinds of silences. Silence was very much a part of my every day in Vietnam, where something would be passed from one person to another in silence.

But every time I was silent in the States, people would be really bothered and unsettled and think that something was wrong or that they had said something unpleasant. But no, I was just really comfortable being silent next to another person. So this is how silence in a film can be amplified and in a way interrupt the viewing experience, and can become aggressive; but actually that very much depends on the viewer.

Viewers should assume their own representative space, in the sense that what they react to or what they see might say something about themselves. It's not always out there, with the film; it's a space that we share. So certain things came

up because I decided on them, but other things appear with viewers in the way they consume images. And, depending on one's relation to silence, one may love it or one may hate it.

XG I want to come back to *The Fourth Dimension*, and the representation of rituals in Japan. In a past interview with film scholar Akira Mizuta Lippit, you said: "What is spiritual is often identified, at least in the modern world, with mystification and institutionalized religion. A return to the traditions of old is also to be rejected as long as these are viewed only through activities of retrieval and of imitation rather than of creation in the present. This, I think, is the very problem we face today, both in the modern East and in the West, with our inability to see the spiritual in any other way than smugly and narrow-mindedly."

Can you tell us more about what you think about the representation of the spiritual world in Japan, and its relation to your camera?

TMH I would start with music. Music is not only in the notes that one hears or in the notes that are being played on an instrument—music is in the ear of the listener. The whole world is music, but we don't hear it. It's a little like the unseen or fourth dimension—we don't really hear it, but when we are in a certain state of mind and body, suddenly we hear it so intensely; every single little thing vibrates and it becomes so intense.

So I would say, similarly, spirituality is not just in the temple. Those who meditate know how much one has to sit

with one's self in order to open up to the realm of silence—the kind of silence that is not opposed to sound, and how in that encounter one actually opens wide to the world.

This is a dimension of spirituality that I brought back when I said, maybe in order to see that spirituality we have to show the ordinary. Spirituality is not just confined to one thing, place, or person.

XG I also wanted to talk about your work as a theorist and a writer, and as a woman artist in this world. As you mentioned, there is a difference between the written woman and the woman who is writing. This immediately made me think of Marguerite Duras, who writes about women and made a film about women, but is also a historic female artist. Can you tell us about these two sides, and how you function between being a writer and a filmmaker?

TMH There are certainly a lot of similarities, but not in the same terms. I have spoken about how one goes into darkness to make film, and how one can demonstrate that knowledge is not what is most important in conveying a situation or even in giving information.

A film can be based on a situation of non-knowing. You can come in without luggage and be very fresh and invite people to watch a film that conveys everything that you see and hear as if for the first time. With writing, I never know what comes in the next sentence.

It's not like I have a plan that I sit down and follow, and yet unfortunately, even now, when I publish books, I encounter publishers who ask me to summarize them. It's mind-boggling, because if you already know everything that you are doing, you

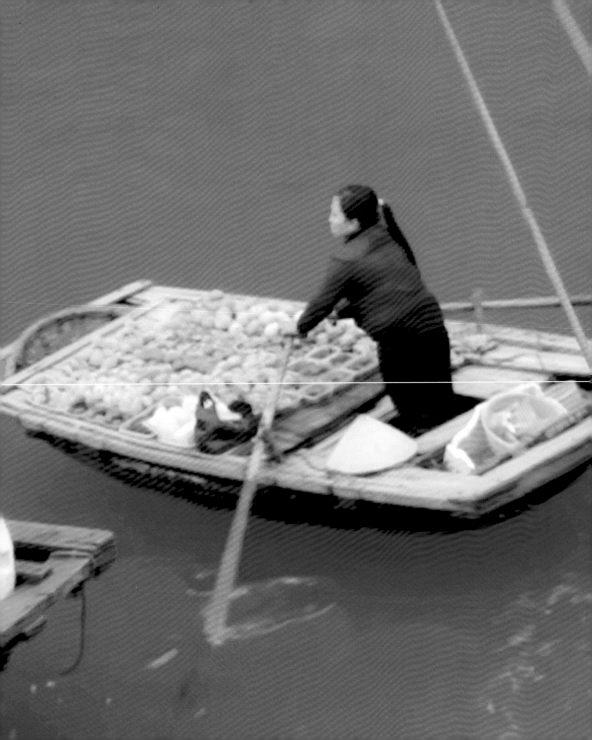

Nước
water

are merely illustrating thoughts you have already advanced. And when you explore, the question of language is at stake.

You don't explore with a language that is entirely familiar and expected. So even if you use exactly the same words as others use, the combination of these words solicit a different relationship.

When I do book readings, I've had women come up to me saying, "You don't write like us." And I ask, "How so?" And they say, "We just don't speak that way," and I'd say, "Oh, fortunately we don't speak the same way!" So if we don't speak the same way and we convey a different kind of relationship, obviously the question of language would have to be modified because language is not a mere instrument for thought or feeling; language is in itself a reality.

When one tends to take language for granted, what one can come up with is a situation in which one's subject is very progressive, but the writing is very regressive. So in a way it works against what you are trying to bring out.

An edited transcript of a talk held on December 6, 2017, at the Institute of Contemporary Arts in London as part of a retrospective program of Trinh's work, this conversation between Trinh and filmmaker Xiaolu Guo was first published as "Trinh T. Minh-ha: Making *The Fourth Dimension*" in *Ocula* on March 2, 2018, in the lead-up to Art Basel Hong Kong in March 2018, on the occasion of the ICA and M+ and Hong Kong Arts Centre's presentation of *Films by Trinh T. Minh-ha* at the Hong Kong Arts Centre, building on the retrospective at the ICA in London. The program was organized in collaboration with the Department of Cultural and Religious Studies, Faculty of Arts, Chinese University of Hong Kong, and in association with Art Basel Hong Kong. The introduction to the interview reads:

"A professor of Rhetoric and of Gender and Women's Studies at the University of California, Berkeley, Trinh studied music composition, French literature, and ethnomusicology at the University of Illinois after leaving Vietnam during the country's war in 1970 at the age of seventeen. As an exchange student, she attended the Sorbonne Paris-IV, and after finishing her PhD, she went on to teach in Dakar, Senegal, for three years. Senegal was the focus of Trinh's first 16mm film, *Reassemblage* (1982), which documents the lives of women in rural Senegal. *Reassemblage* exemplifies the way the filmmaker approaches the subjects portrayed in her films—a position she has described as 'speaking nearby' rather than 'speaking about.' Trinh posits her works as 'boundary events,' existing in a zone between labels—a place where new labels might form or dissolve or cross over one another, and which allows her works to evade categorization. This is enhanced by reflexive cinematic techniques and editorial processes that challenge the traditional documentary form and deconstruct modes of thinking and looking at different cultures. Since *Reassemblage*, Trinh has orchestrated a number of cinematic encounters with cultures from all around the world—including China, Vietnam, and Japan—and has more recently shifted to digital formats. *The Fourth Dimension* (2001), her first digital film, examines the culture of Japan through its art, culture, and social rituals, and once more provides a multilayered dimension in which to consider the effect of video on image making, as well as the use and passage of time in the moving image, and the act of 'seeing.'"

FOR THE FEMINIST VIEWER

Conversation with Irit Rogoff

Irit Rogoff (IR)

I wanted to start by unpacking your film *Shoot for the Contents*, in which there is this extraordinary layering of all kinds of knowledge—mythological, folkloristic, philosophical, poetic, urban, rural, as well as both popular and high culture elements.

Everything seems to operate as an effort to grasp something about this enormity that can't be grasped. Though it's not the fact that it's ungraspable, it's the fact that nothing can be reduced to a single identity. Can you discuss this process of layering?

TMH Yes, I must say that the reason I work with the dragon as a symbol of power is mainly because it has, as an image, gone through many stages. The dragon is supposed to be an animal of people's imagination, but somehow, in the process, it was appropriated as the symbol of power in imperial courts in China, and people were then forbidden to use dragons on their clothes or on furniture, or whatever they might have come up with.

Of course, people didn't go by that rule, because the dragon is an animal that was created by the imagination of the people. And to continue on what you said, this is really the symbol of the people, so why would power appropriate it for itself?

So people continued to use the dragon in their symbolism, and later on, the five-clawed dragon became the image of imperial might, while the four- or three-clawed dragon was renamed accordingly when used among people. As you can see, the politics of naming and representation arises even with the image of an animal like the dragon.

When I was working in China after the Tiananmen Square event, people were very much on edge and were also very suspicious of someone like myself, because at the time there was ongoing conflict between Vietnam and China.

As long as they didn't ask anything, it was fine, because they would just think I was from Beijing and that I didn't speak any of the dialects from the province. But as soon as they found out I'm from Vietnam, people would look at me as though they couldn't believe they were in front of the enemy.

It was a very specific moment in China's history, and one could see it as a trial phase, with much effort to grasp and hold on to something.

At the time, everyone was trying to understand why this massacre of students and workers had happened, and there were many assumptions. But for me, it's mainly that I didn't want to give knowledge to any one faction or to let knowledge of one faction dominate. So that's why you have this variety and multiplicity of knowledges and positions that coexist without anyone being on top or having the last word.

IR

Shoot for the Contents is suspended between, on the one hand, essentialist identity politics that tie down an identity with a very particular representation or a very narrow understanding; and on the other, the entire gamut of postcolonial study and theory that was very present at the time.

The period in which we knew each other well, the '90s in California, was suspended between these two things. How do you place your practice between these two?

TMH

My book *Woman, Native, Other* is very critical of identity and closure; but after finishing it, I encountered many good people who are precisely on the side of raising strong boundaries in terms of identity politics, and I had to step back and accept the fact that these enclosures are created in a very situated context.

Depending on the context, why would people come up with these kinds of boundaries? Not only in relation to the other, but also for themselves? Every wall that is put up is a wall against the other, but also a wall that confines oneself. I had to take that into consideration.

The way that I understand postcoloniality is very different from what people attribute to that term. My take on postcoloniality corresponds very well to what today's decoloniality has claimed. The question of decolonization can be thought of in relation to the '60s, because that's when nations in Africa gained independence.

There are so many things that were written on decolonization, and then suddenly more recently, you have people starting to reclaim the term "decolonization"; it's very weird. But it's something that comes as a kind of cycle.

For me, the "post" of "postcoloniality" has to be put in the context of a notion of time that is not linear. If you put it in the context of linearity, then you can say that "post" comes after colonialism, and is also situated geographically—related only to the countries that have been colonized. But postcoloniality happens now, all the time, right in the White House. Some people might say postcoloniality is over, but it is absolutely not over and has actually spread much wider than the confines that one tends to give colonialism.

Colonialism is not merely specific to a period and a location. It is widespread and persistent and determines the way that we presently think. That's why in relation to the film, I would definitely not only work with my own relation with China, which is a relation of colonizer and colonized.

If I am in Vietnam, that relationship is definitely an antagonistic one, but if I'm in the West, then I can stand with China, because there is a certain solidarity—and the way I bring in the figure of the Black interviewee Claremont in the film is precisely for that kind of solidarity: South-South.

IR

There is a recapitulation of a very traditional kind of colonial perspective on China as an endless market. I was once interviewed to head a national art academy in the Middle East, and at the end of the interview, they asked me if I had any questions, and I said, "I'm actually quite worried that this is a very provincial place; you can't be a national art academy if you're very provincial." And they said, "We too are very worried about this, what do you think about China?" And I thought "China? For this art academy in the Middle East, what's it got to do with China?" And then

I understood that China defined their notion of an international or a global market.

TMH In the example that you give, we can say that sometimes—as related to marginalized and oppressed peoples—you are given the worst to live with, and when you revolt against it you actually accept it in order to reappropriate it to your own ends.

If China has been associated with commerce or trade, it's because that's the part China has also taken on, developed, and has tried to run with even faster than the West, which is a way of turning back and beating the master at his own game. This is what China has picked up and pushes to the maximum in its drive toward modernization.

IR In several of your films that deal with East Asian histories and identities, like *Surname Viet Given Name Nam* and *Shoot for the Contents*, you put the narrative in the hands of women who live out women's histories in a very specific way, and who occupy double and triple positions.

They're traditional characters, contemporary characters, historical, fictional—and there's this slippage all the time, and it's always in the hands of women; it's the women who are performing the multiplicities of identity all the time.

TMH I would say there are two ways to approach "feminist aesthetics" in cinema, and one way is to point toward women as a field of departure. For me, when people talk about feminism as being all about women, I would say no. Although it's important to begin with women as an initial reference from which to depart,

ultimately the goal is not merely women—it's the well-being of society.

Because of the historical repression of women's voices, we can start somewhere that gives women the agency to narrate their situation or the situation of a country. All around the world, there is this tendency to always make women bear the responsibility of the nation's image. In war, for example, rape is prominent as a way to take vengeance; men often collectively rape women from the enemy's side.

Humiliation of the enemy was always through women. So women are made to bear the honor of a nation, and if anything goes wrong, it's their problem. You see that, for example, with Frantz Fanon and "Algeria Unveiled"—it's incredible to take for granted that women have to bear the image of a nation.

So in that sense, yes: I am committed to putting agency and multiplicity in women's voices and to expanding their roles. But one can always see the other side of a "feminist aesthetic," which, more importantly, is not only to focus on women. It's to make films for the feminist viewer.

It doesn't matter if the feminist viewer is a man or a woman; if you give yourself that goal, you'll speak, show, and tell slightly differently, and people can certainly recognize that. Maybe not in a rational way, but you certainly have a difference that is being created just because your goal is not any viewer, but a feminist viewer.

IR

Going back to the notion of decolonization, I agree with you that there's a cyclical eruption of decolonizations, but this moment of decolonization is very much about a recognition that a colonial mindset is something that we're still in the grip of, whether we hold the territories and fortunes of other people in our hands or not.

It's a recognition that the West is, despite all the processes of actual decolonization, still in the grip of a certain colonial mindset that dominates an entire set of cultural values, curricula in universities, and notions of significance and of achievement.

It seems to me that, in that sense, there's a lot of decolonizing going on in your films, and that that decolonizing has to do precisely with the fact that there is no fixed position from which to see something. That the only way to see something is through a multiplicity of positions, of facts and fictions, of political analyses, and giving yourself over to the poetic, to the mythological. You can't just be a "Western rationalist," you have to be all of those things in order to see something.

TMH I think that's very nicely put. Going back to postcoloniality as I expanded on it earlier, if you put it in a linear sense of time, then the "post" is always after. But if you think of time as a spiral, which is how many people in the world receive time, for example among Indigenous peoples like the Maori people, the "post" can be "pre"; it can be before, depending on which way you go.

In that sense, postcoloniality continues to happen over and over again, and in this case there is room for more than one kind of knowledge, and more than one kind of narrative. At the same time, as you refer back to tradition in order to find something different to counter the dominance of Western thought, you are also not caught in tradition; so you have this

situation where you are constantly engaged in at least two movements at the same time.

IR It's one of the fascinating things in the film that you feel the weight of somebody trying to grapple with something that is China and then at the same time an absolute refusal to sustain one way of thinking. Normally, when we are faced with an enormous burden such as class injustice, there's one pathway through which we can organize our political stance militantly; but in your film, you diffuse that one pathway into multiple, myriad pathways, and yet the sense of burden remains.

TMH That's very relevant to mention. You might think of this film as being dated because it was shot just after the Tiananmen Square event. But the situation is still very current, and a main writer, philosopher, and political activist like Liu Xiaobo, who wrote this wonderful poem on June Fourth—because in China it's actually called the June Fourth event, not the Tiananmen Square event—was recently put in prison.

He's the one who got the Nobel Prize in absentia. The chair was left empty, and his absence, and the absence of anyone who could represent him, is very telling of the situation today. So the Tiananmen Square event is what officially the government does not want to be reminded of, and anyone who tries to bring it back to memory has been kept under strict surveillance, if not sent to prison, as Liu Xiaobo was.

IR One of my favorite texts of yours is called "Cotton and Iron," and it

starts with a situation where a story-teller is recounting a tale to a group of listeners, but he interrogates the tale, asking, "Tale, are you truthful?" There's a kind of constant interrogation of the very form that you're enacting and performing.

I wanted to ask you about that within filmic practice: that constant disruption of the ability to comfortably settle in the film and know where you are. In a way, you're asking the film all the time whether it's truthful, whether it has the capacity to convey what it claims.

There's something about not quite giving in to the illusion of film by questioning its veracity, its capacities, and being a little dubious about its ability to create perfect illusion.

TMH Definitely! I think we can see it as a critical approach to cinema, but I think we can also see it simply as a way of tuning in to the nature of cinema, the nature of image.

When I look at myself in the mirror, my image is there where I am not. It's simply the nature of reflection, the nature of an image that you're pointing to.

Thank you very much for that association between the beginning of "Cotton and Iron" and the questioning of film images. Unfortunately, the reflexivity at work in my films often tends to be confused with a form of breast-beating and self-criticism.

For me, reflexivity is so much wider because it's not only about yourself. You yourself are a reflective surface, and hence when you are trying to reflect something to yourself, it comes right back to you.

But on the other hand, reflexivity can happen between one element of cinema and another element. Someone tells a story, and suddenly someone else, without intending it, tells another story, and the two stories suddenly reflect one another, or one story comments on the other, for example. So that kind of reflexivity again breaks with linearity, and in that reflexivity, every time you show and tell something—it shows you, or you show something about yourself.

What we see in an image is a manifestation of how we see it, so the "what" and the "how" are always together, and self-reflexivity is a way of expanding and receiving the world.

An edited transcript of a talk held on December 7, 2017, at the Institute of Contemporary Arts in London as part of a retrospective program of Trinh's work, this conversation between Trinh and Irit Rogoff, professor of Visual Cultures at Goldsmiths, University of London, was published in *Ocula* under the title "Trinh T. Minh-ha and Irit Rogoff on Feminist Aesthetics and Cinematic Reflexivity" on March 2, 2018, in the lead-up to Art Basel Hong Kong in March 2018, on the occasion of the ICA and M+ and Hong Kong Arts Centre's presentation of *Films by Trinh T. Minh-ha* at the Hong Kong Arts Centre, building on the recent retrospective at the ICA in London. The program was organized in collaboration with the Department of Cultural and Religious Studies, Faculty of Arts, Chinese University of Hong Kong, and in association with Art Basel Hong Kong. The introduction to the interview reads:

"A multi-layered enquiry into the shifting culture and politics of China post-1989, Trinh's 1991 film *Shoot for the Contents* is distinctive of the fimmaker's approach to cinema as a means of deconstructing modes of thinking and seeing. This intricate, cinematic layering reflects on a statement made by Chairman Mao Zedong in 1956, 'Let a hundred flowers blossom and a hundred schools of thought contend,' and enters a complex and poetic exploration into questions of power and change, politics and culture against the backdrop of the Tiananmen Square crackdown in 1989. Infusing popular songs and classical music, as well as intimate footage of various subjects and stylized interviews—the film confounds viewers who seek a traditional, informative documentary format and offers instead an insight into the creative processes of filmmaking."

SOUNDSCAPES OF MULTIPLICITY

Conversation with Stefan Östersjö

Stefan Östersjö (SÖ)	How would you describe your engagement with the sounds of cities in the process of making *Forgetting Vietnam*?
TMH	Vietnam is very much an agricultural country, with at least 80 percent of its people living in rural areas. So although the three main cities, Hà Nội, Huế, and Sài Gòn (or Hồ Chí Minh City), serve as one of the referential threads in *Forgetting Vietnam*, marking the film's trajectories across the three main regions, rivers, and linguistic variations, its soundscapes alter drastically between urban and rural, and from one location to another.
	For me, and perhaps for most musicians attentive to the sound environment, working with soundscapes, whether in the city or in the countryside, merely requires an active reception of what is perceived as "noise" and an ear unconstrained

by musical training. So, for example, what loses pertinence are the very hierarchies set up between music and "ambient sound," or between silence and sound. In the context of film and video, this would also mean a predisposition for a free play between synchronized, off-sync, and non-sync sound, as well as between musical composition, improvisation, and indeterminacy. Such a path of the "musically unbound" actually requires a precise, demanding work of multiplicity.[1]

Cities have their own sonic imprints. One recognizes their soundscapes the way one remembers faces. Sometimes this ability comes with attentive listening, but at other times it catches one by surprise as it surreptitiously arises with memory. To give just one example, the frequency with which people resort to honking while driving, the way they beep, blow, blare, hoot, and whistle, is quite distinct from city to city. It is a language of its own. Hà Nội traffic can be crazy and loud, especially in the old quarter. In their density and frequency as well as in their tone, dynamics, and speed, horns and bells of cars, scooters, mopeds, cyclos, and bikes play a unique role in defining the aural identities of cities like Hà Nội, Huế, and Sài Gòn.

In *Forgetting Vietnam*, you can also hear the differences of the clamor of the streets in terms of times and temporalities: the same city caught on camera in Hi8 in 1995 and then in HD in 2012 shows dramatic changes, not only visually, in the content of the images, and technologically, via the analog and the digital, but also aurally, via differing sound fabrics that include fragments of popular songs dear to radio media during certain periods of Vietnam's history. Viewers are quick in identifying an era or a period through images, but they are much less attuned to how the sonic and the musical also designate time; more specifically, how besides being a powerful sensorial experience, a film soundtrack is multivoiced, multitextured, and multitextual, just as complex, significantly informative, and interpretive as the visual and optical.

In the city, whether one stays in a place or walks through a neighborhood, if one remains all ears to the environmental

soundscape, one would be struck by the overwhelming wealth of sounds in coexistence and co-formation. Short fragments of popular songs played on the radio mingle with animal, human, and mechanical noises of all sorts. Arising in the city's sonic fabric are the diversely textured street vendors' calls, children's laughter, dogs' yapping, and people's vocal interactions against a host of local labor sounds. These do not really clash with one another; they resonate as a multiplicity. In *Forgetting Vietnam*, there is, for example, a multilevel conversation unfolding both between the older and more recent soundscapes of the same city, and between the differing urban-rural, human-nonhuman, high-tech–low-tech, liquid-solid, and water-land soundscapes.

SÖ

It strikes me as one of the central characteristics of *Forgetting Vietnam* how it is as much a cinema for the ears as it is a documentary film. One component in the work of the Six Tones on collecting materials for the film was driven by the thematic threads related to water and land in Vietnamese history and mythology. We carried out fieldwork in the Bắc Ninh region to record Quan họ songs relating to these themes. This is a tradition which is very much alive in the countryside north of Hà Nội, and when work is over for the day, people may gather in a master singer's house to join in. The songs heard in the film were all recorded in the house of Nguyễn Thị Bướm, a female master in her eighties, sometimes singing solo, and sometimes together with her daughter and

granddaughter. In a small village like Ngang Nội, Quan họ singing still characterizes the soundscape in the evening, merging with the sound of cicadas, domestic animals, and occasional motorbikes.

TMH Yes, I was happy to have Nguyễn Thị Bướm's Quan họ in the film; it was a real gift of yours, and especially of Thanh Thủy and her aunt. Besides being a recognized cultural heritage, carrying with it the quality of the communal characteristic of a village's soundscape, the inclusion of Quan họ is also personally dear to me. As per my mother's and grandmother's stories, this folk music and its historical "antiphonal" nature used to be such a lively event—a call-and-response mode of singing exchanged between a pair of female and male singers during the rice-planting season, which remains amazing, both in its improvisations and in its playful love-and-seduction undertones.

Each city, each neighborhood has its own multisonic assemblage. By giving ear to it, I usually use music—mainly the music produced by your collective, the Six Tones—so as to prolong and highlight the sounds of everyday life and, further, to take them into the realm of an "elsewhere within here." For example, in the sequence of boats shown at the beginning of the film, it is the various motor sounds of the boats in motion, the rhythmic creaking of the boats anchored (or of metal moving with the lapping of water), and later, the cadenced rowing (wood against water) that motivates accordingly the choice of the musical sections put to use. What is heard as banal and familiar in an everyday soundscape thus subtly changes before the spectator realizes it and catches on in the process. Rendered fluid and mobile, the relation between composed music and the sounds of daily life is worked on, both so as to ground the viewers' relation to the subject on-screen and to unsettle that relation, by drawing attention

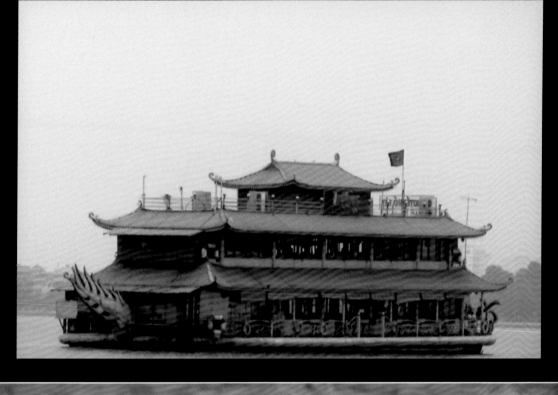

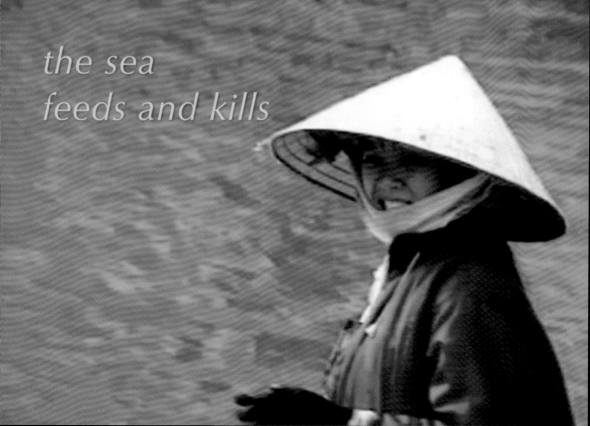

*the sea
feeds and kills*

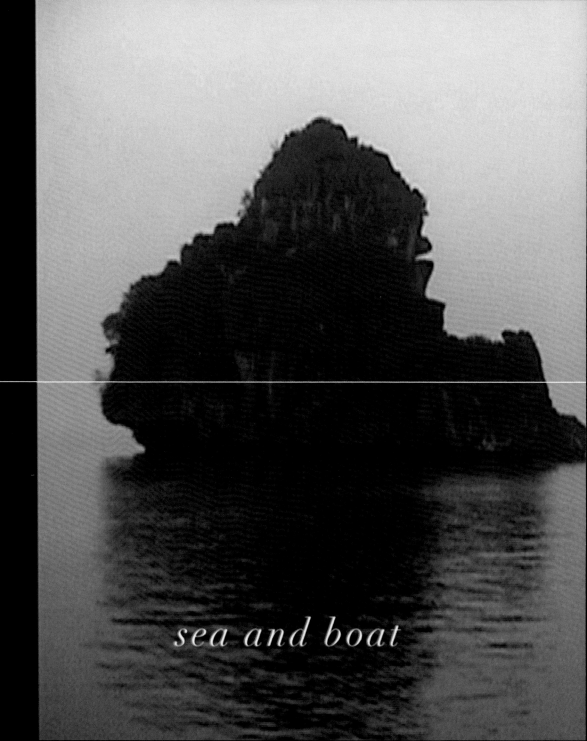

sea and boat

*what
would
they
be
without
each
other?*

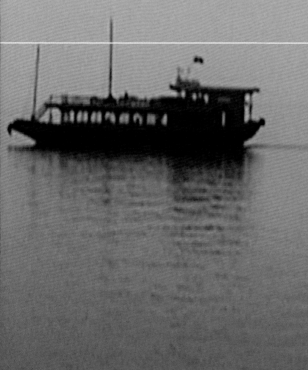

water of legends

to hearing and to the dimension of the sonic and the musical in film experience.

In mainstream films, all is geared toward achieving the "realism effect." Music primarily performs a secondary role of underscoring and enhancing the images, and filling in what they lack, while sounds are reduced to Foleys or to the reproduction of everyday sound effects. Thus, to generate a change in conventional listening and to bring the spectator's awareness to the aural realm, what is often made to enact a structural role in my films is acousmatic sound and acousmatic listening (off-screen sounds or those sounds one hears without seeing the source cause). The ear is not made to serve the eye, and rather than providing the images with the realism they lack when shown in silence, the role of the soundtrack is to create a multisensorial, multifunctional space in which many relations between the seen (and unseen) and the heard (and unheard) are possible.

SÖ There are some other emblematic sonic elements, one being the train, recorded in a journey from Hà Nội to Sài Gòn. How would you describe your work with the train recording? We also recall the signal processing we employed to transform these recordings when the scenario shifts in the film.

TMH The train is a trans*[2] character in my work. It was already featured in two previous films of mine. In *The Fourth Dimension*, it constitutes one of the two main characters, the other being the drum; these are the two rhythms that characterize the way Japanese culture negotiates between the ancient and the modern. In *Night Passage* (2004), a film inspired by Kenji Miyazawa's novel *Milky Way Railroad*, the train takes on a protagonist role in the life-and-death journey of two young women. In *Forgetting*

Vietnam, the train again plays an important role. It is linked to the way the film unfolds as a conversation between land and water—the two elements underlying the formation of the term "country" (*đất nước*) in Vietnamese. Here, the encounter happens between the ancient as related to the solid earth, and the new as related to the flow of liquid—the two forces that regulate life and can be traced back to every beginning and ending, more particularly to the geological formation of Vietnam's Mekong and Red River deltas. As first explored in my installation *Old Land New Waters*, this nonbinary Two generates a third space: that of memory and forgetfulness in the realms of history, culture, and family.

The sound and rhythm of a train anchors one to the earth, while the sound and rhythm of the boat invites one to let go and float. In 1995, we mainly circulated by bicycle, moped, and pedicab, and took the train to travel from North to South via Huế. When I returned in 2012 we mostly traveled by car and bus, and flew from Hà Nội to Sài Gòn. But the boat was used extensively in both travels. A large part of Vietnamese culture is river-born, and Vietnam is, in its core, a water body. The necessary equilibrium between water and land therefore plays a fundamental role in the country's economics and politics. It was then important to include in the film the means of transportation that determine the ways one sees or hears the country. This was done by featuring the sound of the old train I took in 1995, which was clanging away along window views of the scorched landscape and of the extensive wet rice fields.

It is in this context of sound, rhythm, memory, and forgetfulness that we can further discuss the link between the recorded and the transformed that you raise in your question. One of the most exciting processes for me in this film was to work with the Six Tones' music. There is a happy encounter or something like a kindred spirit between the way I work in sound-and-image montage and the way your collective combines the *arrière* and avant-garde—namely the experimental, electronic, and concrete in music with the ancient and traditional.

I remember when I first heard you, Stefan, and Henrik Frisk in a performance at the New Music Center in Berkeley. I was struck and very excited by the processes of "metamorphosis" in your music, and this also came back to memory when I decided that the sound of the train should go beyond its recorded state. In working with the interconnected nonbinary between memory and forgetfulness, I first introduced the recorded sound of the old train so as to invite the audience to listen more intensely to the train sound in its amplified stabilizing cadences, and then in its transformation—how it "liquefies" and "etherealizes" with your and Henrik's intervention—and further, to forget so as to remember more intensely how, ultimately, every sound image on-screen is actually an image of memory. To remain creative and to keep the field of possibilities open, one listens to the becomings of reality's recorded sounds and soundscapes. And for this, the Six Tones' music plays a primary role.

SÖ

The director Jörgen Dahlqvist and composer Kent Olofsson have also collaborated extensively with the Six Tones. In a recent paper, they analyze the artistic strategies they have developed within experimental music theater as a vertical dramaturgy—by reference to Ruth Finnegan's claim that writing is multimodal in ways similar to performance—and they advocate a multilayered conception of music theater, in which layers of music, text, scenography, and acting are sometimes independent but also aligned, both horizontally and vertically, within the dramaturgy of the composition.[3] It seems to me that *Forgetting Vietnam* develops a

similarly contrapuntal relation between its elements.

TMH It is very relevant to introduce this dramaturgy of composition in relation to the multiplicities at work in film. Such a notion of vertical and horizontal dramaturgy can also apply in terms of substance and surface, or what I often call the within, the between (inter), and the across (trans*) in arts and politics.

What is most questionable is the widespread reductive tendency in mainstream productions to fold the space of the verbal over that of the visual or the musical, and hence to reduce these to the functions of illustrating, explaining, and duplicating. Rather than being one of subordination and domination, the relation between the verbal, the musical, and the visual could remain, at the core, one of multiplicity.

Viewers have asked me why in *Forgetting Vietnam* there is no voice-over, as in my other films. But the "voice" of the film is here already so richly manifested through a tapestry that weaves together Vietnamese classical music (the *đàn tranh* as performed by Nguyễn Thanh Thủy), popular songs, recited poetry, folk music, avant-garde composition, and everyday sound art, that I prefer to leave the verbal commentary to the eye, together with the selected translations of the singing and the local people's comments and interactions. Since *Forgetting Vietnam* takes the viewer through the three regions of Vietnam with a focus on the rich activities on the Red River in the North, the Perfume River in the center, and the Mekong River in the South, the differently accented voices of the people on- and off-screen—bus and taxi drivers and riders, street vendors, boat passengers, performers of traditional, popular, and folk music, for example—are not only used for cultural and political reasons, but are also indicative of each of the regions through which the viewer is led. Film as music for the eye and editing as composing are bound to be at once visual, textual, and musical.

1 James Gifford's discussion of Lawrence Durrell's *Avignon Quintet* strikes a very similar note to Trinh's reference to multiplicity here. Gifford points to how the first book, *Monsieur*, mirrors the structure of the entire cycle, by being "divided into five independent sections where authorship of the book is brought into question. It is this constant remembering of the authorship—or constructed nature of fiction—which most strongly brings the reader's mind to the epistemological crisis, and refutes the concept of the work revealing a single absolute truth. *Monsieur* is a work of multiplicity." James Gifford, "Reading Orientalism and the Crisis of Epistemology in the Novels of Lawrence Durrell," *CLCWeb: Comparative Literature & Culture: A WWWeb Journal* 1, no. 2 (1992): 7. Gifford further suggests that Durrell's project aims to replace "our sense of an absolute truth derived from our sensory experiences with a realization of the necessarily multiplicitous and unrealizable nature of absolute truths" (Gifford, 4), in a manner very similar to Trinh's claim that there is no such thing as documentary: "On the one hand, truth is produced, induced, and extended according to the regime in power. On the other, truth lies in between all regimes of truth. To question the image of a historicist account of documentary as a continuous unfolding does not necessarily mean championing discontinuity; and to resist meaning does not necessarily lead to its mere denial. Truth, even when 'caught on the run,' does not yield itself either in names or in filmic frames; and meaning should be prevented from coming to closure at either what is said or what is shown. Truth and meaning: the two are likely to be equated with one another. Yet, what is put forth as truth is often nothing more than a meaning. And what persists between the meaning of something and its truth is the interval, a break without which meaning would be fixed and truth congealed." Trinh T. Minh-ha, "Documentary Is/Not a Name," *October* 52 (Spring 1990): 76.

2 Jack Halberstam proposes that the use of the asterisk "modifies the meaning of transitivity by refusing to situate a transition in relation to a destination, a final form, a specific shape, or an established configuration of desire and identity. The asterisk holds off the certainty of diagnosis; it keeps at bay any knowing in advance what the meaning of this or that gender form may be, and perhaps most importantly, it makes trans* people the authors of their own categorizations." Jack Halberstam, *Trans*: A Quick and Quirky Account of Gender Variability* (Oakland: University of California Press, 2018), 4.

3 Jörgen Dahlqvist and Kent Olofsson, "Shared Spaces: Artistic Methods for Collaborative Works," *Studies in Musical Theater* 11, no. 2 (2017): 119–29.

This conversation was originally published as part of "Attentive Listening in Lo-fi Soundscapes: Some Notes on the Development of Sound Art Methodologies in Vietnam" by Stefan Östersjö and Nguyễn Thanh Thủy, in *The Bloomsbury Handbook of Sonic Methodologies*, ed. Michael Bull and Marcel Cobussen (New York: Bloomsbury, 2021). All footnotes by Stefan Östersjö.

IN THE SPIRAL OF TIME

Conversation with Domitilla Olivieri

Domitilla Olivieri (DO)

For a special issue that focuses on postcolonial intellectuals and filmmaking, it seemed immediately necessary and obvious that your voice had to be included. Yet, at first, I had some resistance in asking you to take part in this conversation, because of some of the connotations attached to an idea of the intellectual. When thinking of "the intellectual" as a geopolitically and historically located figure, one cannot but think of undertones of romanticized individualism and superiority that have to do with a certain tradition of European politics[1]; as well as

with the radicalized, gendered, and classist connotation of "intellectual" as speaking to a mind-body, reason-emotion Cartesian and Western hierarchy of values.[2] While this understanding of the term has been amply challenged and unsettled by Marxist, feminist, and postcolonial scholars,[3] I detect the protracted presence of a kind of intellectual figure in the mainstream contemporary arena, which carries with it the persistence of individual exceptionalism, maintained by ignoring the collective and collaborative emergence of certain ideas. For these reasons, and knowing your written and cinematic engagements with issues of subjectivity, relationality, differences, communities, politics, and temporality, I hesitated in approaching you with this topic. Yet, precisely for these very same reasons, it seemed extremely appropriate to invite you to partake in this interview, and to start by asking how you relate to the idea of the intellectual, especially in relation to your artistic and filmmaking practice.

TMH I thought your focus on the intellectual as filmmaker was interesting because our world is very binary and people in the film industry, for example, consider all documentary films to be issues films. So, documentarians are supposedly all having some kind of issue, and are bound to deal with some kind of problem. We cannot even dream, for example. In such a con-

text, any film that makes you think is immediately rejected as being "didactic," "difficult," or "complicated." It is not uncommon for me to get viewers' reactions such as, "Why can't we just say something simply?" As if the simplest things are not also the most complex, especially when the very person asking took many convoluted turns to get to such a question.

The way people raise questions is usually very complicated. This is why I think it's relevant to refocus on the pensive image or on cinema as research and exploration, as in my context. Partly because I have what some call a dual career: on the one hand, as a filmmaker, writer, music composer, and visual artist; on the other hand, as a scholar, a university professor and researcher. How these two careers (rather than being "dual," they are actually a multiplicity) have often been set up against each other is strongly experienced in my daily reality—for example, in how you are not fully accepted in any milieu, be it that of film, art, music; creative, political, or academic writing; how you are (mis-)presented or (mis-)located in public events, or how you are praised and rejected, made to feel special and diminished at the same time. You are always an "inappropriate other" as I have previously written, and it's necessary to go into this duality and see how we can work with it.

Well-known are the pitfalls of intellectualism, and the cocooned context in which intellectuals function, the kind of vain role we could play, and the way groundless, freewheeling products of the mind are centralized and venerated. These could just go on unfolding without much concern for how they fare in daily reality and communal lived activities. With the case, for example, of structuralism and poststructuralism, the question that arises often concerns how positioning proves to be political, even and especially when it disclaims its politics. In a feminist, postcolonial context, to take positions begins with, let's say, understanding how everyday language used to name and define our world is far from neutral, and how ordinary thinking predominantly functions by the light of

Western metaphysics. In my everyday reality, there is also a basic difference between the intellectual and the academic, since not every academic is an intellectual, and vice versa, intellectuals are not necessarily academics. Similarly, "theory" is often loosely claimed in an academic framework, but worth noting is how theoretical writing remains rare among academics. Such a differentiation is important in the setting of US universities because the question of what an intellectual is and what theory is often tends to be taken for granted.

For me, more than being defined by the link to a university, the academic's identity has to do with the compartmentalization of knowledge and the dependence on systems of "expertise." The academic operates within disciplines, and often treats knowledge as acquisition via accumulation. Whereas the intellectual could refer to a function whose engagements expand much wider—such as locating oneself as a member of humanity or nonhumanity, or as a vessel for world events in the everyday. More specifically here, as a creative recipient for cinema, music, and the other arts engaging forms of thinking that, while focusing on the specific, would be relevant across contexts, locations, and times.

So, we are dealing immediately with the production of knowledge, and the diverse forms by which it is spread and circulated, like the production of discipline and discursive modes; the centralization of master narratives; and among others, the consolidation of systems of evaluation according to set categories with their mechanisms of exclusion and marginalization. Rather than complying with these control-and-discipline by-products of the mind, often related to entrenched academic work, intellectuals try to engage further, by returning to basic questions of existence generated by a certain situation, a certain community, and applicable across cultural contexts. In doing so, you also question the limit and the scope of your own role, your accountability, your daily activities, and the tools that define your creative work.

This is what puts the intellectual, and especially the public intellectual, at stake: always coming back on the work itself and situating its production processes—so that the critical finger raised does not simply go the other, but also comes back to oneself.

DO

This connects to another aspect that scholars have associated with the idea of the intellectual, that is, the question of audiences.[4] You wrote that "Each work made is for me, a bottle thrown into the sea," which hints at which audiences you speak to or with, or rather at how you relate to your audience. I wonder if this has something to do with the transnational—if we want to use the prefix "trans"—dimension of your work that exists in the content matter of your films, as well as in how your books and films have been traveling. You have discussed the complexities of experiences and theorizations of traveling, crossing, and traversing on other occasions, but I am wondering how you relate this to your own practice as an intellectual, as a filmmaker, and as an artist, since such roles are said to speak to defined and possibly different audiences.

TMH

I've gotten a lot of questions around audience. I've also given a lot of answers concerning audiences. That's one of the first things people always ask when they encounter a film, a writing, or a project in which not everything is immediately accessible to their own knowledge, or simply anything that

presents a thinking outside the box and doesn't abide by the conventional criteria of logical positivism. In the repetitious question "Who is your audience?" I could often detect a covert hostility ("If I don't understand, then who could?" or "I could understand, but what about the others?"), which I attribute to the person querying not giving enough credit to the audience. We come into a film with a multiplicity of backgrounds, and it is with this multiplicity of views that my film offers different pathways, different entries and exits to each viewer. There is more than one door to choose, and any person in the audience can have an access of their own that is not merely personal when they engage with the film's workings.

The question about a film's audience often hides the fact that the spectator thinks the film is not accessible and takes for granted that their reaction could be representative of general audience reception. But no one should take on that kind of role of *speaking for* the audience, because even in a dominant context the audience is highly diversified. For example, academics do not necessarily understand my films better than others—especially those who act as experts or authorities in their fields. The same applies to art audiences: when they come to see a narrative film of mine like *A Tale of Love*, they react to it with the same expectations as those any consumer of commercial films has, looking for story, plot, conflict, acting, meaning, and message rather than entering through the door of the sensual thinking body or through the dimensions of affect, for example. When one makes film not merely "to cater to the needs of the audience" (a favorite line from the film industry), one is bound to work with uncertainties: rather than preexisting the film, the audience is what I have been building across cultures and contexts with every single film I have made.

I remember the first time *Reassemblage* was screened, there was only one viewer in the room aside from the programmer. But we had a good discussion on the film afterward. And even though it's a bit sad to have only one viewer

at a public screening—since every filmmaker would have loved to share the film with more people—the fact that I had one deeply engaged viewer was already a success. Building my own audiences with each film is part of how I see independent filmmaking. The audience does not simply exist out there, with needs you must cater to. This is the mainstream mindset, for which the relation to the spectator is that of a commercial supplier to the mass market. Far from being a consideration for the consumer, as the question suggests, it's all about control and lining the supplier's pockets. For me, saying there is an audience out there whose needs you must respond to is very irresponsible. Further, audiences need not be viewed only in terms of numbers or ticket sales, but also in terms of diversity and ability to reach across communities, cultures, national and transnational contexts, and more.... I have, in that sense, a very wide audience for my films and cannot ask for better.

DO

In addition to the very prominent role the market and other economic aspects have in mainstream Hollywood cinema, there is also a widespread yet implicit norm in commercial cinema: the idea of clarity (or transparency); the expectation that a film must be clearly legible, clearly visible, that it must represent something, or tell a story, in an unambiguous manner. Instead, throughout your projects you have in many ways resisted, or at least worked within and between, any sharp and obvious demarcation of what we can call the visible and the invisible. In your films, you have engaged with the complexities and implications

of making sense, of sensing. So, in relation to the transnational or wide reach of your work, at the same time as you address very specific stories and social and cultural contexts, there is also an engagement with a very broad scale of relations, as you touch on questions of time, memory, visibility, subjectivity, etc.

TMH In the previous question you raised concerning the transnational dimension of my work, the term "trans" itself could be viewed across many contexts. "Transnational" could sound quite suspicious, as it often applies to multinational corporations and their economic powers—the 1 percent that owns a disproportionate portion of economic wealth in the US, versus the 99 percent, as the 2011 Occupy movement called it. One could easily recognize how corporate mentality thrives in the film industry, and how the public's evaluation and consumption of movies remains conditioned by the marketing mind. Transnationality in that context does not interest me, but "trans" in terms of an event in itself, and "trans*" with an asterisk, for example, as a way to indicate indefinite inclusion in gender and sexuality, is for me very significant in its scope. It implies not only that the crossing is indeterminate, but also that this crossing, this in-between, is actually the very place of dwelling, the place where you can affirm an identity or take a stance in your undertakings.

That's how I would situate my work: in that very place of the "trans"—transcultural, transnational, transdisciplinary, transgressive, transgendered, transpositional (as in music). We are dealing here also with the multi- and trans-sensory— both the integration and the crossing of different senses while going beyond them. People usually think of cinema as primarily visual—an art for the eye. It's not wrong. But for me, it's certainly not what makes the film, because we have other senses that

are very important, like the musical and sound dimension, the hand and the haptic dimension. Further, ancient East Asian literature speaks, for example, of "listening to incense" and of "eating wisely" in reading. There's no linear logic for the senses. A film could touch not simply the eye, the ear, or the mind, but the whole of the body. In other words, cinema is an experience of the body. Voice and rhythm, for example, are elements that could affect the body very strongly, and in certain films of mine, like *A Tale of Love*, I was trying to deal with the senses of smell and taste as well, even though we know that in cinema these senses are very difficult to convey.

DO Staying a bit longer with this aspect of the aesthetic, and considering how politics and aesthetics are related to each other in your films, I wonder if you can elaborate a bit more on the body, on rhythm, on the "how" of your filmmaking, which speaks to an embodied, political way of relating to the world.

TMH As related to the trans space discussed earlier, my films have been categorized in many different ways; some of the categories are clearly contradictory while others are quite fine. It's just that I'm not quite there, in the category given. I'm either at the edge of it or somewhere else. For example, one of the categories attributed to my work is the "essay" or "essayistic" film, which is fine; it is used to designate Chris Marker's films as well. And although not a genre, it has become a popular category, claimed for a wide number of "new" documentaries in the last decade. That being said, I have also received feedback from people who said that as a genre-breaker, my films are totally anti-essayistic [*laughs*]. So, again, I'll come back to the notion of trans as something that is not quite here, not quite there; something that is in between, but you can

always be here and you can always be there. All depends on how one performs the essay—as a transformative way of raising questions so as to invite people to expand their reality further, or as a conventional analysis steeped in expository and explanatory reading. How about a "trans essay" film?

Because of their embodied practice and politics, as you've just pointed out, sometimes people also qualify my films as "personal" or "subjective." This may come from the attention given in my films to the intimate realm of affect, in which the viewer's "hearing eye" and "seeing ear" are actively solicited. But again, these films are neither subjective nor objective, because such a binary based on the duality between subject and object is not relevant to my context. The way I work with film is to let events come to me—intimately, not indifferently. There's an outside-in movement in the "documentary" approach that lets the world come to you. And there's an inside-out movement in the "fictional" approach that leads you toward the world from within yourself. Those two movements are always overlapping.

With such inefficient categories I find myself constantly unnaming, not naming, and naming anew. The same applies to the notion of crossing and transgressing boundaries. Some people think of my films as travel film, or, even worse, as "travelogue." The term could be used in its focus on "travel," but that category has nothing to do with the films I make. If we use the word "travel," we would have to open it up. What is traveling here? Is it simply opposed to dwelling? Reformist anthropologists may have been dealing with travel practices in relation to their textual products, but conventionally, the movement of the researcher is always that of mobility—going to places to do research—while the subject studied is considered to be static—available for data gathering and retrieving. For me, there's no such binary in the relation of traveling and dwelling; each has its own intrinsic movement. In this sense, we are always traveling in life, and we dwell while traveling. We are traveling in every daily activity, even if we stay in the

2012
Vietnam via High Definition Video

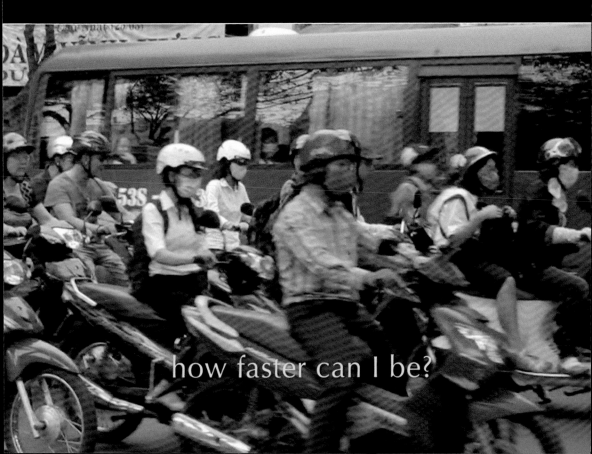

how faster can I be?

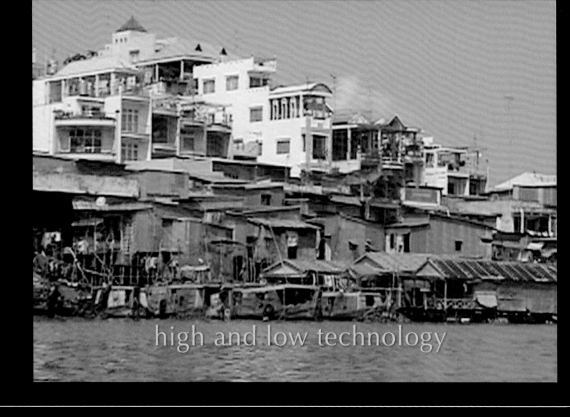

high and low technology

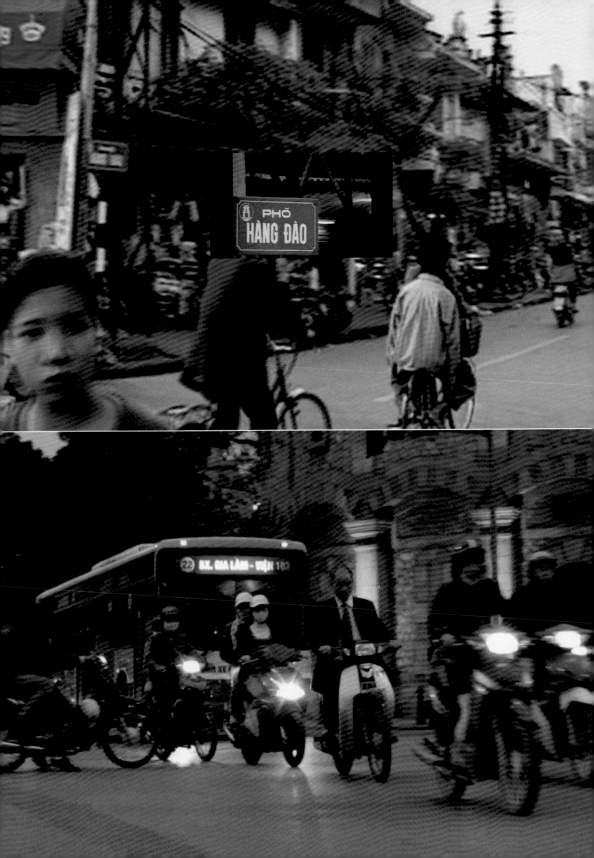

1995
Vietnam via Hi-8 video

same place—the way, for example, the spectator sitting in one place is traveling with film and with video. I would accept the term "travel" as such, used in its transformative sense, as it leads us back to the notion of "trans" discussed earlier.

DO We could maybe even add that, instead, the more prevalent understanding of "travel" is loaded with associations of travel as discovery, as appropriation of the other, and its attendant colonial implications, which is precisely the opposite of what your films do. So, I want to come back to your filmmaking in the sense you talked about earlier, as a process in which "the world comes to you" (possibly as "the world comes to walker").[5] This is another aspect that makes your films very distinct from a certain kind of essay film that has a specific end-goal, already somewhat predetermined from the beginning. Conversely, you have spoken about your process of making films as one of encounter. How do your films emerge from encounters, and how does an initial idea become a film despite, or thanks to, the uncertainty of what that encounter will entail?

TMH If my films are different from other filmmakers' works that I love, it's mainly because of the way one engages basic notions such as, among others, those of the individual and the communal or of the external and the internal. These need not be binaries. When you go to a place, the question of encounter is very important, because you can do all the research

you want before and yet not carry around the knowledge-baggage. What happens in an encounter is an in-between that belongs to neither self nor other. And film itself is a form of research, albeit one in which every single step taken involves the processes of filmmaking and building audiences: writing, shooting, editing, music composing, public debate, and more. These are all based on materials that do not preexist but come with heightened attention as body and mind go on the alert in the encounter.

I would not necessarily come into a project by having some personal idea or feeling ahead of time—even though I can only make a film when I feel very passionate or strongly about the subject. However, the film doesn't come merely from ideas or subjects. It comes from the whatever . . . the processes by which the material comes to you—or as previously mentioned, from letting the world come to you at every step. The focus here is not on projection—the way colonials hubristically talked about discovering the world, while the world was already there. Columbus's "discovery" was not really a discovery. In my film *What About China?* (2021), one of the Chinese narrators actually mused on the fact that by 1405, almost a century before Columbus embarked on his voyage, the Chinese marine explorer Zhenghe had already traveled around the world seven times. So, the world is there; emphasis could be given here to receptivity or to travel as a mode of reception rather than to self-projection via "discovery." How do you receive? This is a praxis I would attribute to a feminist stance, because women are tuned to reception rather than mere projection; to receiving life and nurturing it rather than being driven by destruction. . . . In going forward, one also knows when, where, and how to go backward, or to stay put in order to receive. This walking so as to receive the universe is very important. In film, the material that comes to me tells me the way each film should be made. There is no center per se, whether that center is a subject that you have chosen, or yourself. The film comes together in a multiplicity of relations.

DO — Another feminist characteristic recurrent in your approach to filmmaking is the intention of provoking a new seeing, rather than only producing a new image.[6] I find this extremely relevant, especially in a time of proliferating production and sharing of images, including images of critique and resistance to inequalities and injustice. To what extent is this one of the ways in which your work as a filmmaker becomes an act of political, as well as artistic, intervention?

TMH — Here we come back to the notion of the intellectual. Take any verbal statement in my films, for example. Each is written in such a way as to have at least two dimensions: one related to the culture, the people, the subject of research, or what is shown on the screen; and the other pertaining to the properties of film or video and the collaborative process of its formation. This is what I've called the twofold commitment. Placing oneself as an intellectual, that is, as a member of the human or the nonhuman, one engages a specific subject while reaching out wide, across locations and contexts. And this double commitment doesn't stop there. It would further provoke other nonbinary ways of thinking capable of shifting our mind, as it grounds itself in what we call reality only to expand it. In other words, the true discovery doesn't come with the seeking of new contents or new technology, but with the advent of a new seeing.

When you're trying to get out of the box, being in a box is also very important. The film is in a way a box because it offers you a framed reality. A frame can be very confining, or it can provide you, via its very presence, an opportunity to undo it indefinitely. This is what thinking, speaking, showing

outside the box entails. So, to provoke a new seeing, it is not enough to focus on odd subjects and produce new images with a feat of technology; you would have to challenge the old seeing—yours included—and work on both the internal and external realm of the "how" and the "what" of the film. In other words, your film would have to address the *feminist viewer*, who could be of any gender.

In the feminist struggle, there is also a dualistic situation of content versus form, or vice versa. Certain feminists are mainly focused on content or on women as content, while others are more concerned about the master's house and the master's tools that determine the way women make films and receive films. One does not go without the other, but the second approach tends to be more invisible, and hence remains critically more important, not only to filmmaking, but to the filmmaker as the first viewer of the film. You're both maker and viewer and could easily put yourself in the consumer's shoes. That's why even though every film made is a bottle thrown into the sea, working with the audience is not contradictory. The viewer's look is always incorporated in my films, but the audience does not drive the film. As research, the film is still a groping in the dark, waiting for the form to manifest itself to the maker-cum-viewer. The film *Reassemblage*, for example, offers you a way to turn the mirror around. Looking at Senegal, or at women and Senegalese village life, you are also looking at yourself looking at them. Here, the reflexivity at work functions not only between film and viewer, but also between all the elements of cinema and its apparatus: how they interact with one another, how they affect and trans-form one another in the process.

DO

Is this also why you resist the notion of a dualism between form and content, and you talk about rhythms, forms, in the plural, and forces, as crucial aspects of filmmaking and

as a framework that avoids reproducing a clear-cut separation between the how and the what?

In other words, it seems to me that rhythm, and the way you work with rhythms, is a not fully graspable yet very embodied force, an undercurrent that significantly drives your films.

TMH You have pinned down a strong drive in my films. I consider a work without rhythm to be flat, unmusical, and hence, lifeless. It will not succeed, for example, to bring to life the situations you powerfully experience in lived contexts. A strike could appear so weakened on-screen, as compared to what you have experienced on-site. You have to work with the properties of cinema or video to resurrect its lived power in relation to the body. Rather than simply showing a weakened event, you are re-creating its impact as an embodied experience. So, rhythm is not merely an aesthetic device in my films. Working on rhythm could open up to all kinds of relations in the film. You can see, hear, or experience rhythm with your whole body. Rhythm felt in touch, taste, smell, or thoughts could all be explored.

Looking at two or four women pounding millet together in an African village, for example: while one goes up, the other goes down; why is it that they never clash with their pestle? Isn't it a question of both innate bodily rhythm and social rhythm? Pounding in counterpoint is what allows for the seamless performance of this activity day in and day out, without any collision. This is one way of looking at a film. Another way of looking at it is through the rhythm of the visible and the invisible. As in every struggle, we like to think of our action as that of bringing to visibility what has been kept invisible. And because "invisibility" is often the condition of marginalized groups, we fight for visibility and claim the space of

representation for ourselves. But this is just a step in the struggle, for it is in the very forms of visibility that invisibility is also generated. In Hollywood films, giving women a main role, for example, is not necessarily empowering women; it all depends on how one treats the main role, which can be very disempowering when it comes to women's agency. Women could be visible, but only in certain roles and contexts endorsed by patriarchal society. Here, visibility actually heightens women's invisibility.

What is visibly shown in the film is not necessarily what determines a strong cinema experience. Sometimes you need to speak directly to bring out something indirect. Other times you need to go through the indirect to bring out something direct. When you work on your body, doing yoga, for example, you're not just doing some physical exercise. You go through the physical to act on the nonphysical. Activating the field of energy that we each are is an ancient practice in Asia. Film practice is quite similar; if you are not attentive to the undercurrents of the film, to the forces that underlie the film, then you are just exerting eye effort. Certain spectators said, "Well, anyone can make *Reassemblage*," and I agreed: technically, anyone can make it. But the one thing you cannot reproduce, which remains unique to each one of us, is the spirit of the film. Its field of energy, its rhythm, its light—visible and invisible—its embodied experience.

DO

When talking about the visible and the invisible, I was thinking about *Forgetting Vietnam*), in terms of telling a history that is felt and experienced, but not necessarily visible. In the film there is a way of working with the visible and the invisible that challenges a certain Western conception of time wherein present, past, and future are understood

as distinct moments on a supposedly unidirectional line. *Forgetting Vietnam* is also, in a way, a return to a place where you worked before, and of course, a place you have a personal connection to. In this context, the question of legacy emerges for me. Although it might seem an unfitting question considering your way of working with nonlinear times and temporalities, I am interested in hearing how you relate to your own work in terms of your past, present, and future projects. More specifically, how do you approach this question of time in relation to your legacy or your experience of it?

TMH This links very well with the question of visibility and invisibility. In cinema, time is the fourth dimension. I've precisely made a film called *The Fourth Dimension* related to my encounter with Japan and with the digital film event (also the title of one of my books). The question of time and of new technology as related to the small, the portable, and the mobile is very prominent in the experience that I had of the culture. A compelling dimension of film that often remains invisible on-screen, time is strongly experienced via the body. Time, conveniently conceived of as past, present, and future, could, in the relation between the West and the Rest, or between modern and ancient, lead to a series of damaging "mis-" and "dis-es": misinterpreted, misconceived, misjudged; discriminated, disfranchised, disallowed, etc. Even terms like "poststructuralist," "postmodern," or "postcolonial" are often misunderstood as an "after" in linear time, but for me, time is a spiral: we are going in continuously widening or tightening curves, but we never come back to the same place as in circular

motion. As such, does the post come before or after? Is it the nascent, thriving, or dying phase of a movement?

In my take on new technology, or what I called the digital *way*[7]—a path rather than a technique or a technology—there's no binary between old and new. On the contrary, what is at the forefront of new technology actually leads us back to ancient practices and puts us in connection with—how should we call them?—wise people, our ancestors. The virtual, the dimension of nonbeing in being, is very prominent in ancient Asian thinking; between the visible and the invisible, there's the barely visible, the unseen-and-yet-there, the "flying white" and the void, for example. These aspects are very important in thinking about time and space. Linear time could so impoverish our reality as to leave us stranded in illusory classifications. In "post-" what comes before, during, and after all meets, not in the present, but in now time—the very moment of consuming or of making, the immediate time of an action or nonaction. Not quite temporalities, but the now of spiritual practice. Time in its spiraling course enables us to evoke "memories of the future" (*Forgetting Vietnam*) and to see how the future is already in the past, and the past in the present.

For me, legacy comes in multiplicities—in gifts received from my many encounters with events, communities, and people who have left a strong impact in my life. For example, you have the legacies of Indigenous societies, which deeply inspired me when I wrote on storytelling in *Woman, Native, Other*.[8] You have the legacies of African American playwrights, whose works I was introduced to when I first came to the States; they have informed the way I worked in Africa. Here, the archival is not limited to the written or to the material world; rather, it pertains to a rigorous ear capable of preserving genealogies, oral history, and memory, and trained to excel in music, poetry, as well as public speaking. People carry whole archives in their body—the archival body.

Of course, you also have the legacies of ancient East Asian arts, with which I fare quite well, but even here, you

never go back to the same point. Tradition for tradition's sake is rather spiritless. You return to the ancient to create a new seeing—a different way of living that expands with nonbinary thinking, which for me is also what underlies the feminist struggle. "Nonbinary" could be carried out in every dimension of life. It's always a twofold commitment, but each one of the two or twos in my context is a multiplicity. When mountains and rivers appear in ancient East Asian thinking, they refer to forms and forces that regulate our lives—masculine and feminine, solid and liquid, immobile and fluid, high and low, etc. So in speaking to old and new technology, rather than referring to what comes before and after, one could focus on the fact that our market-driven society never fails to make old and new incompatible. Incompatibility regulates the relation between old and new in our throwaway society. Techies often tell you, "Oh, this is old technology, no longer supported after three years. We have to move ahead. Better buy a new one." But actually, what does "moving ahead" mean in the spiral of time? It could be simply going back and back and back, but never to the same point.

At the core of this discussion on time and legacies in feminist and postcolonial practices also lies the question of criticism. For me, critical thinking is a creative activity. Let's say you're doing critical work on a text by Clarice Lispector—a writer I find most inspiring. You are not simply talking about her writing or her text, you are also creating something like a second track to go with it. Criticism is not a mere matter of pointing a finger to something that is external to your own practice, since you can't turn a blind eye to the form of your own writing and thinking. And vice versa, what is called art is also critical thinking. Filmmaking as research is a form of thinking itself.

DO

To conclude, I want to come back to something we touched on at the beginning, but now return to it through these nonbinary and nondualistic

frameworks you have articulated in relation to art and critical thinking. We talked about how your work as an intellectual encompasses your activities as a filmmaker, an artist, a writer, as well as a teacher and academic. We also discussed the risks and the limitations in neatly categorizing your artistic and cinematographic practices as distinct from your academic interventions. I am wondering if, for you, there is something about approaching art and critical thinking through the lens of spiral time, and inside-out and outside-in movements, that also points toward a different understanding of the very act of knowledge production, and therefore maybe also of the feminist, postcolonial intellectual.

TMH Yes, we can close this multithreading conversation here. We don't always have to operate with the knowing mode, approaching a subject as if we have to know all about it, and have that knowledge be unquestionably wrapped up for the spectator. A non-knowing mode, which is not ignorance, allows us to wander, wonder, and start afresh. Challenging history, his-story, or Western historicization in its linear accounts of events has been a recurrent thread in my films, more comprehensively so in the film *What About China?* Equally important in the politics of representation is the emphasis on the transformative everyday and on multivocality in its poetic, musical, *and* discursive dimensions. That being said, as a proverb in *What About China?* goes, "A bird does not sing because it has an answer. It sings because it has a song."

1 See Gayatri Chakravorty, *The Postcolonial Critic: Interviews, Strategies, Dialogues* (New York: Routledge, 1990); Jane Hiddleston, *Decolonising the Intellectual: Politics, Culture, and Humanism at the End of the French Empire* (Liverpool: Liverpool University Press, 2014).

2 See Patricia Hill Collins, *On Intellectual Activism* (Philadelphia: Temple University Press, 2013); Genevieve Lloyd, *The Man of Reason: "Male" and "Female" in Western Philosophy* (London: Methuen, 1984).

3 See Sandra Ponzanesi and Adriana José Habed, *Postcolonial Intellectuals in Europe: Critics, Artists, Movements, and their Publics* (London: Rowman & Littlefield International, 2018); "Postcolonial Intellectual Engagements: Critics, Artists and Activists," ed. Sandra Ponzanesi, special issue, *Postcolonial Studies* 24, no. 4 (2021); Edward W. Said, *Representations of the Intellectual: The 1993 Reith Lectures* (New York: Vintage, 1994); Stuart Hall, Paul Gilroy, and Ruth Wilson Gilmore, *Selected Writings on Race and Difference* (Durham, NC: Duke University Press, 2021).

4 Trinh T. Minh-ha, "Don't Stop in the Dark," in *Politics of Memory: Documentary and Archive*, ed. Marco Scotini and Elisabetta Galasso (Berlin: Archive Books, 2017), 172.

5 Trinh T. Minh-ha, *Lovecidal: Walking with the Disappeared* (New York: Fordham University Press, 2016), 53.

6 Trinh T. Minh-ha, *The Digital Film Event* (New York: Routledge, 2005), 13.

7 Trinh T. Minh-ha, *D-Passage: The Digital Way* (Durham, NC: Duke University Press, 2013).

8 Trinh T. Minh-ha, *Woman, Native, Other* (Bloomington: Indiana University Press, 1989).

Originally published in the July 2022 issue of the journal *Transnational Screens* as "In the Spiral of Time: Conversation Between Domi Olivieri and Trinh T. Minh-ha," this discussion, in Olivieri's words, "emerges from a longstanding feminist and postcolonial engagement with subjectivity, filmmaking, critical thinking, temporalities, and the politics of representation, that both interlocutors share. Professor Trinh T. Minh-ha, as a renowned filmmaker, scholar, writer, and artist; and Domitilla (Domi) Olivieri, as a scholar and activist who has written on and grown alongside Trinh's work, meet here to discuss Trinh's relation to the figure of the intellectual as well as to traverse together her multidimensional filmmaking (and) research practices."

All footnotes in the original.

INTERVIEWS PRINTED
IN THIS BOOK WERE
PREVIOUSLY PUBLISHED AS

"Trinh T. Minh-ha with Benjamin
Schultz-Figueroa and Patricia
Alvarez," *Brooklyn Rail* (Octo-
ber 2016), https://brooklynrail
.org/2016/10/film/trinh-t-minh
-ha-with-benjamin-schultz
-figueroa-patricia-alvarez.

"Reality Is Delicate," interview
by Erika Balsom, *Frieze* 199
(November–December 2018):
13–39.

"Forgetting Vietnam," interview
by Lucie Kim-Chi Mercier,
Radical Philosophy 2, no. 3
(December 2018): 78–89.

"Trinh T. Minh-ha: Making *The
Fourth Dimension*," interview
by Xiaolu Guo, *Ocula*, March 2,
2018, https://ocula.com
/magazine/conversations
/trinh-t-minh-ha-part-one/.

"Trinh T. Minh-ha and Irit Rogoff
on Feminist Aesthetics and
Cinematic Reflexivity," *Ocula*,
March 2, 2018, https://ocula
.com/magazine/conversations
/trinh-t-minh-ha-part-two/.

"Forgetting Vietnam: A Conver-
sation About Sound Art and
Memory," interview by Stefan
Östersjö, in Stefan Östersjö and
Nguyễn Thanh Thủy, "Attentive
Listening in Lo-fi Soundscapes:
Some Notes on the Development
of Sound Art Methodologies in
Vietnam," in *The Bloomsbury
Handbook of Sonic Methodologies*,
ed. Michael Bull and Marcel
Cobussen (New York: Bloomsbury,
2021), 487–95.

"In the Spiral of Time:
Conversation Between Domi
Olivieri and Trinh T. Minh-ha,"
in "Screening Intellectuals:
Cinematic Engagements and
Postcolonial Activism," ed.
Sandra Ponzanesi and Ana
Mendes, special issue,
Transnational Screens 13, no. 2
(July 2022): 176–88.

*All interviews reprinted with
permission.*

OTHER BOOKS BY
TRINH T. MINH-HA

Traveling in the Dark,
Mousse Publishing, 2023.

*Lovecidal: Walking with
the Disappeared*, Fordham
University Press, 2016.

D-Passage: The Digital Way,
Duke University Press, 2013.

*Elsewhere, Within Here:
Immigration, Refugeeism
and the Boundary Event*,
Routledge, 2011.

*Vernacular Architecture of
West Africa: A World in
Dwelling*, with Jean-Paul
Bourdier, Routledge, 2011.

*Habiter un monde: Architectures
de l'Afrique de l'ouest*, with
Jean-Paul Bourdier, Alternatives,
2005.

The Digital Film Event,
Routledge, 2005.

Cinema Interval, Routledge, 1999.

Drawn from African Dwellings,
with Jean-Paul Bourdier,
Indiana University Press, 1996.

Framer Framed, Routledge, 1992.

*When the Moon Waxes Red:
Representation, Gender and
Cultural Politics*, Routledge, 1991.

*Woman, Native, Other: Writing
Postcoloniality and Feminism*,
Indiana University Press, 1989.

En minuscules, Le Méridien
Éditeur, 1987.

*African Spaces: Designs for
Living in Upper Volta*, with
Jean-Paul Bourdier, Africana
Publishing Company, 1985.

*Un Art sans oeuvre, ou,
l'anonymat dans les arts
contemporains*, International
Book Publishers, 1981.

OTHER FILMS MENTIONED

What About China? 2021, 135 min., digital, color. Distributed by Women Make Movies.

Night Passage, 2004, 98 min., digital, color. Distributed by Women Make Movies; Freunde der Deutschen Kinemathek; British Film Institute; I-GONG.

The Fourth Dimension, 2001, 87 min., digital, color. Distributed by Women Make Movies; Freunde der Deutsche Kinemathek; British Film Institute; I-GONG.

A Tale of Love, 1995, 108 min., 35mm, color. Distributed by Women Make Movies; Freunde der Deutschen Kinemathek (with German subtitles); British Film Institute; Image Forum; I-GONG. Print with Chinese subtitles at the Golden Horse Taipei Film Festival Archives.

Shoot for the Contents, 1991, 102 min., 16mm, color. Distributed by Women Make Movies; Image Forum; I-GONG; National Film & Video Lending Service.

Surname Viet Given Name Nam, 1989, 108 min., 16mm, color and b&w. Distributed by Women Make Movies; British Film Institute; Freunde der Deutschen Kinemathek; Third World Newsreel; MoMA (New York); Image Forum; I-GONG; National Film & Video Lending Service.

Naked Spaces: Living Is Round, 1985, 135 min., 16mm, color. Distributed by Women Make Movies; British Film Institute; Freunde der Deutschen Kinemathek; MoMA (New York); Light Cone; I-GONG; National Film & Video Lending Service.

Reassemblage, 1982, 40 min., 16mm, color. Distributed by Women Make Movies; Third World Newsreel; British Film Institute; Freunde der Deutschen Kinemathek; MoMA (New York); Light Cone; Image Forum; I-GONG; National Film & Video Lending Service.

FILM DISTRIBUTION

ARSENAL - Institut für Film und Videokunst
Freunde der Deutschen Kinemathek
Potsdamer Straße 2
10785 Berlin, Germany
arsenal-berlin.de

BFI Distribution
21 Stephen Street
London W1T 1LN, England
bfi.org.uk

I-GONG Media Theater /
Alternative Visual Culture
Factory
(03715) F2 43, Susaek-ro
Seodaemun-gu, Seoul,
Republic of Korea
igong.or.kr / nemaf.net

Light Cone
157, rue de Crimée, Atelier 105
75019 Paris, France
lightcone.org

Women Make Movies
115 West 29th Street, Suite 1200
New York, NY 10001, USA
wmm.com

SELECTED FILMS ARE ALSO AVAILABLE AT

Image Forum
2-10-2 Shibuya, Shibuya-ku
Tokyo, 150-0002, Japan
imageforum.co.jp

National Film & Video Lending
Service
Cinemedia Access Collection
222 Park Street
South Melbourne 3205,
Australia
cinemedia.com.au

Museum of Modern Art,
Circulating Film and Video
Library
11 West 53rd Street
New York, NY 10019, USA
moma.org/research-and
-learning/circulating-film/

Third World Newsreel
545 Eighth Avenue, Suite 550
New York, NY 10018, USA
twn.org

Doc Alliance Film
Online viewing (SVOD, TVOD)
outside the United States:
americas.dafilms.com
/spotlight-on/1106-trinh-t
-minh-ha-there-is-no-such
-thing-as-documentary
Ostrovní 126/30, 110 00 Praha 1,
Czech Republic
dafilms.com

The Twofold Commitment
© 2023 Trinh T. Minh-ha

Editor: Rachel Valinsky
Designer: Dorothy Lin
Copy Editor: Allison Dubinsky

Interviews in this book, dated 2016–2022, are © Trinh T. Minh-ha and their respective authors: Patricia Alvarez Astacio, Benjamín Schultz-Figueroa, Erika Balsom, Lucie Kim-Chi Mercier, Xiaolu Guo, Irit Rogoff, Stefan Östersjö, and Domitilla Olivieri.

Primary Information
232 3rd Street, #A113
The Old American Can Factory
Brooklyn, NY 11215
www.primaryinformation.org

ISBN: 978-1-7377979-6-8

Printed by Grafiche Veneziane, Italy

The artist would like to express her profound gratitude to Jean-Paul Bourdier, architect, visual artist, photographer, and film producer, with whom she has worked as a team throughout the years and to whom this creative journey remains deeply indebted.

The texts published in this book, which have previously appeared elsewhere, have been lightly edited for style, clarity, and consistency.

Primary Information would like to thank Hiji Nam, as well as each contributor to the book, and the publishers Bloomsbury Publishing, the *Brooklyn Rail*, *Frieze*, *Ocula*, *Radical Philosophy*, and *Transnational Screens*.

Image stills from *Forgetting Vietnam* (2015, 90 min., digital, color) © 2015 Moongift Films

Primary Information is a 501(c)(3) non-profit organization that receives generous support through grants from the Michael Asher Foundation, the Patrick and Aimee Butler Family Foundation, The Cowles Charitable Trust, Empty Gallery, The Fox Aarons Foundation, the Graham Foundation for Advanced Studies in the Fine Arts, the Greenwich Collection Ltd, the John W. and Clara C. Higgins Foundation, Metabolic Studio, the New York City Department of Cultural Affairs in partnership with the City Council, the New York State Council on the Arts with the support of the Office of the Governor and the New York State Legislature, the Orbit Fund, the Stichting Egress Foundation, VIA Art Fund, The Jacques Louis Vidal Charitable Fund, The Andy Warhol Foundation for the Visual Arts, the Wilhelm Family Foundation, and individuals worldwide. Primary Information receives support from the Henry Luce Foundation, the Willem de Kooning Foundation, and Teiger Foundation through the Coalition of Small Arts NYC.

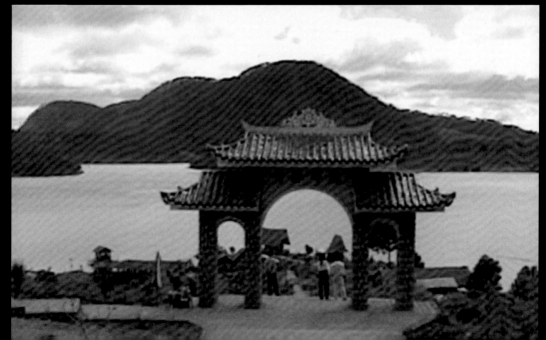

it
all
began
with
two

sea and boat